IN FOCUS

ANDRÉ KERTESZ

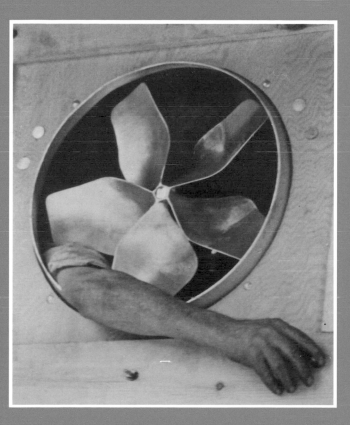

PHOTOGRAPHS *from*

THE J. PAUL GETTY MUSEUM

Born in 1894 in Budapest, André Kertész was loved and admired as a "photographer's photographer." His work spanned more than sixty years in a remarkable career that took him from his native Hungary to Paris and, finally, New York City, where he lived from 1936 until his death in 1985.

Kertész created some of the most acclaimed photographs of the twentieth century, and the J. Paul Getty Museum is fortunate to own a wide selection of his work. This volume—the first in the Museum's new In Focus series, which is devoted to photographers whose work is particularly well represented in the Getty—presents a handsome selection from the 164 Kertész photographs in the Museum's collection.

The photographs are accompanied by commentaries by Weston Naef, the Getty's Curator of Photographs, who knew Kertész well. Mr. Naef was also one of the participants in an informal colloquium—held in New York City in 1993—at which five friends and associates of André Kertész discussed his life and career and assessed his accomplishment as a modern master. Excerpts from this unique discussion are included in this volume, along with a chronology of significant events in Kertész's life.

In Focus: André Kertész presents an intimate look at the career of one of the great photographers of modern times.

IN FOCUS

ANDRÉ KERTÉSZ

WITHDRAWN

PHOTOGRAPHS

from

THE J. PAUL GETTY MUSEUM

The J. Paul Getty Museum

Malibu, California

In Focus
Photographs from the J. Paul Getty Museum
Weston Naef, *General Editor*

© 1994 The J. Paul Getty Museum
17985 Pacific Coast Highway
Malibu, California 90265-5799

Christopher Hudson, *Publisher*
Mark Greenberg, *Managing Editor*

Library of Congress
Cataloging-in-Publication Data
Kertész, André
 In focus. André Kertész: photographs
from the J. Paul Getty Museum, Malibu, California.
 p. cm.
 ISBN 0-89236-290-1
 1. Photography, Artistic. 2. Kertész, André.
3. J. Paul Getty Museum—Photograph collections.
4. Photograph collections—California—Malibu.
I. J. Paul Getty Museum. II. Title. III. Title: André
Kertész.
TR653.K4713 1994 94-8379
779'.092–dc20 CIP

Contents

Foreword

This is the first in a series of small monographs devoted to the art and life of photographers whose works are held by the Getty Museum in particular strength. The centennial of André Kertész's birth in 1994 gives us a reason to begin with him.

Laid out in a book, the work of Kertész looks perfectly at home. To Kertész, seeing his pictures on the printed page was as important as seeing them exhibited, for he was at heart a chronicler whose images are visual reports, skillfully combining fact and interpretation.

The text is the result of a discussion held on June 14, 1993, in the Council Room of the Grolier Club in New York City. We would like to thank the participants, who are all intimately familiar with Kertész's life and work: Robert Gurbo, Sylvia Plachy, Weston Naef, and David Travis. Charles Hagen moderated the discussion and edited the transcription, reducing and rearranging where necessary.

We are grateful for the hospitality of the Grolier Club and to Martin Antonetti, Librarian, William McClure, Business Manager, and the staff of the Club for their assistance, as well as to Melvin Simmons, sound engineer, and Ted Panken, transcriber. At the Getty Museum Julian Cox, Curatorial Assistant, Elizabeth Daniels, Intern, and Jean Smeader, Senior Office Assistant, all of the Department of Photographs, assisted in research and logistics. The André and Elizabeth Kertész Foundation generously funded Robert Gurbo's work and made materials available for study.

I want to acknowledge once more our debt to Weston Naef, whose years of friendship with Kertész provided a special motive for the book and lend particular interest to the commentaries he has supplied for the photographs.

John Walsh, *Director*

Introduction

A few facts about André Kertész's life are essential to understanding his art. Born in Budapest, Hungary, on July 2, 1894, he took his first photograph in 1912, in his spare time from his job as a clerk at the Budapest stock exchange. Drafted into the Austro-Hungarian army in 1914, he was wounded in 1916 and released in 1918. In 1925, at the age of thirty-one, he left Budapest for Paris, where he became a freelance photographer and his signature visual style evolved. In 1936, at the age of forty-two, he emigrated to the United States and settled in New York City, where for more than twenty years he devoted himself to photographing architecture and interiors designed by decorators. He retired from commercial work in 1962, at the age of sixty-eight, in order to have once again the freedom of an amateur photographer to delight in the commonplace things and situations that had been his favorite subjects in Hungary and France. He continued to photograph until his death in 1985, at the age of ninety-one.

The plates in this book are reproduced from the collection of the J. Paul Getty Museum, which includes 164 Kertész photographs acquired between 1984 and 1993 from various sources, including the photographer's estate. They have been selected to profile the strengths of the Getty's collection of Kertész photographs and to survey as broadly as possible the diverse aspects of his work over his long career.

André Kertész. *Self-Portrait*, 1926–27.
Gelatin silver print, 13.4 x 7.5 cm.
93.XM.21.2.

Helpful in appreciating Kertész's photographs as objects are the history of his darkroom practice and his ever-shifting ideas about how his prints should look, which is an aspect of photography that can be suggested but not conveyed completely in reproductions. Kertész always worked with portable cameras that yielded small negatives, which were never more than four by five inches in size. Most of his negatives from Hungary are two by two and three-eighths inches in size, and when contact printed yield miniature images that are notable for their graphic strength. Surprisingly, none of the surviving enlargements of Kertész's Hungarian negatives were made in Hungary; the enlargements of those images that have been shown in various exhibitions were made decades after the pictures were taken. In this book Kertész's contact prints have been reproduced at their original size.

Kertész began to make finely crafted exhibition prints in Paris, where he used for his favorite negatives a photographic paper with a very soft tonal scale; each sheet was preprinted on the back for use as a postcard, with separate blocks for the message and address. Kertész never put these jewellike images, fastidiously printed to achieve rich shadow detail and silvery highlights, naked into the mail. He would often make just two or three prints on this *carte postale* stock, sometimes leaving a large margin for creative effect, or trimming the cards to suit his compositional needs. Usually he would sign the prints on the front in his elegant, minuscule handwriting. In these years Kertész also began to enlarge his negatives, both for exhibition and for reproduction in the new photo-illustrated magazines. Typically he would enlarge these press prints to six by eight inches, using relatively low-contrast, single-weight papers of serviceable but not brilliant quality.

In Paris Kertész made his own prints, and he continued to do so in New York until about 1950, when an allergy to photographic chemicals forced him to hire assistants to do this work. A major turning point in Kertész's attitude toward his negatives occurred in 1963, when he recovered a hoard of them made during his Paris years that had been stored at a country house in France during World War II and the German occupation. In the 1960s he returned to these old negatives, some of which were now broken. Most had never been printed, while

others Kertész had not seen since he left Paris nearly thirty years before. He approached the old negatives as though he had just made them, sometimes cropping them radically to create new compositions. In this way the act of printing these rediscovered negatives became both a contemplation of time and a gesture of perception.

Kertész loved to present his work in small, soft-cover books like this one. When he visited Los Angeles for the first time in 1985, soon after the Getty's Department of Photographs was established, he suggested the idea of publishing a series of small catalogues of works from the collection, of which this is the first. In order to reflect the spontaneity of Kertész's manner, the texts I have written to accompany the images here rely heavily on remarks he made in conversation. Often these texts are based on things Kertész said about the pictures in question.

Following the plate section is an edited transcription of a colloquium that was held in New York City on June 14, 1993, devoted to Kertész photographs in the Getty Museum collection. Each of the participants was a friend of the photographer. Sylvia Plachy is a Hungarian-born photographer who lives in New York, with whom Kertész shared a friendship based on a mutual respect for each other's photographs and a shared heritage and native language. Robert Gurbo is a photographer who became Kertész's assistant in 1978 and is now Curator of the André and Elizabeth Kertész Foundation. David Travis is Curator of Photography at the Art Institute of Chicago and was the lead partner with myself and Sandra Phillips in organizing the 1986 exhibition *André Kertész: Of Paris and New York* and its catalogue. I first met Kertész in 1971 in New York. He lived a few blocks from my home, and I saw him nearly every week, when we would talk about photographs and other matters of mutual interest.

The participants were invited to share unpublished information about the photographs under consideration and encouraged to express their opinions and to speculate about connections between Kertész's life and work, in addition to reporting facts. The colloquium moderator was Charles Hagen, art critic for the *New York Times.*

Weston Naef, *Curator, Department of Photographs*

Plates

**A Note About
the Dates of the Photographs**

André Kertész would often
make prints from negatives he
had made years, sometimes
decades, before. In the informa-
tion that accompanies the plates
that follow, the date immedi-
ately underneath the title of a
photograph is the date on
which the negative and its print
were made; later prints are
indicated by a second date.

PLATE 1

Lovers

1970s gelatin silver print
from a 1915 negative
19.7 x 24.5 cm
84.XM.193.12

For Kertész in 1915, photography was
little more than a self-taught hobby that
he had been pursuing on weekends for
about three years; it was a diversion from
his weekday job at the Budapest stock
exchange. A handful of the pictures created
when he was between nineteen and twenty-
one years old show signs of true genius.
Despite these early indications of extra-
ordinary talent, however, Kertész did not
decide to make photography his life's
work until a decade later. Here we see an
acquaintance named Jacob Lieberman
romancing his fiancée on an outing to
Pest's Nepliget Park a few months before
their marriage. The tender emotions
projected by the subjects are balanced by
the formal authority of the composition.

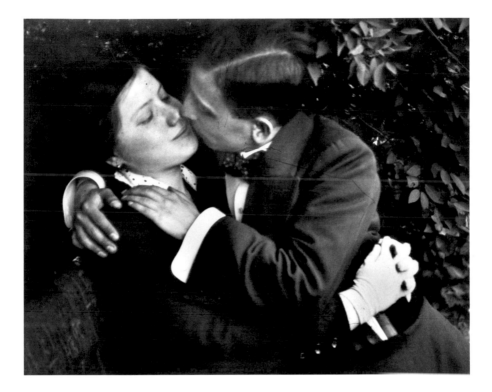

PLATE 2

Gypsy Children
November 10, 1916

Gelatin silver print
3.9 x 5.1 cm
86.XM.706.17

Kertész's life was disrupted by his con-
scription into the Austro-Hungarian army.
An artist at heart but not yet in name,
he was not content with regimented military
life. He was, however, granted abundant
free time, which he used to practice photog-
raphy. His objective was to record life
in rural Hungary, such as these three gypsy
children camped near his regimental out-
post. Kertész recalled that the children were
scavenging clothes using a wheelbarrow
to transport their finds.

Kertész made one or two contact prints
like this soon after making his early nega-
tives, and few, if any, enlargements. He put
the early negatives into storage when he left
for Paris in 1925 and did not return to them
for four decades. This, for example, is the
only surviving print made before the 1970s
from this negative.

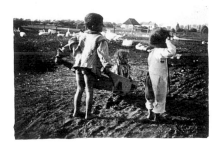

PLATE 3

Underwater Swimmer

1970s gelatin silver print
from a 1917 negative
17 x 24.7 cm
84.XM.193.11

Kertész saw the world through the eyes
of the incurable romantic, as exemplified
by *Lovers* (pl. 1); he also viewed it with
analytic intelligence, as exemplified by this
photograph of a man undergoing physical
therapy for a war injury.

Modernism in photography was being
invented in New York between about 1915
and 1917 by Alfred Stieglitz (1864–1946),
Paul Strand (1890–1976), and Charles
Sheeler (1883–1963), but their works had
not yet been seen in most of Europe.
Kertész made this remarkable study with-
out the benefit of knowing Strand's Cubist-
influenced still life arrangements or
Sheeler's Dadaist-influenced architectural
studies of 1916–17.

At the heart of photographic Modern-
ism is ambivalence, the quality of a work
simultaneously expressing two conflicting
ideas at once. The conflicting ideas here
are stasis and motion. The subject is
actually static, but the artist has infused it
with a sense of dynamic action.

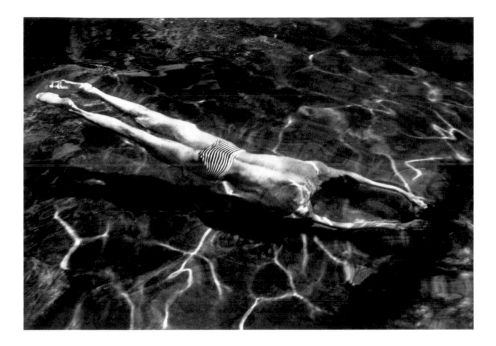

PLATE 5

The Dancing Faun

1919

Gelatin silver print
5.6 x 10 cm
85.XM.259.18

If we are to judge from the photographs alone, Kertész enjoyed a fairy-tale life in his native Hungary with his two brothers, Imre (1890-1957) and Eugenio (1897-?). "We were 'sportive,' we three brothers We went swimming, running, mountain climbing— everything," he remembered sixty years later. To create this picture he cajoled his younger brother into stripping to the skin and performing. "He had the body of the good athlete that he was and a fine head for a faun," Kertész recalled, thus explaining how a work of visual fiction could be structured around a core of truth.

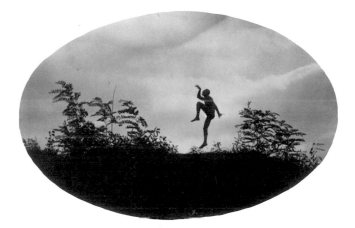

PLATE 6

The Circus, Budapest

1970s gelatin silver print
from a May 19, 1920, negative
24.7 x 19.7 cm
84.XM.193.36

In 1925 Kertész bought one of the first preci-
sion miniature (35-millimeter) cameras to
appear on the market, but even before hav-
ing this new tool he had made spontaneous
studies using a larger camera with glass
plates. "I worked from the start in the Leica
spirit, long before the Leica existed,"
Kertész reminisced while studying a port-
folio of his early work. *The Circus* is typical
of the way in which Kertész achieved spon-
taneity with a camera that used glass plates.
"I photographed real life—not the way
it was but the way I felt it. This is the most
important thing: not analyzing, but feeling,"
he recalled. Better than nearly any other
of his early pictures, *The Circus* presents an
intuitive perception by the photographer
about a particular time and place. The
couple are peeking at performers out of our
sight behind the fence; the man appears
to have just one leg. The composition is less
about the seen than the unseen.

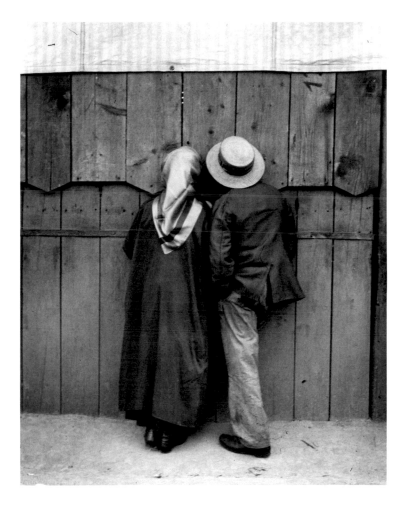

PLATE 7

Wandering Violinist, Abony

1970s gelatin silver print
from a July 19, 1921,
negative
24.7 x 19.7 cm
84.XM.193.35

In the summer of 1921 Kertész began to
think seriously about his future. The cre-
ative side of his personality had begun to
compete with the practical side, and he
obtained his mother's permission to leave
his clerical job to go and live with an artist
in the village of Abony. The man was
also a beekeeper and introduced Kertész to
beekeeping. Kertész came to see this as a
practical lesson in controlling the seem-
ingly uncontrollable, a skill he felt was at
the heart of photography. Kertész was lured
from his Abony room by the sound of a
violin playing and created this photograph
representing a universally affecting situa-
tion. The image recalls *Organ Grinder and
Street Singer* by Eugène Atget (1857–1927),
made in Paris twenty years before.

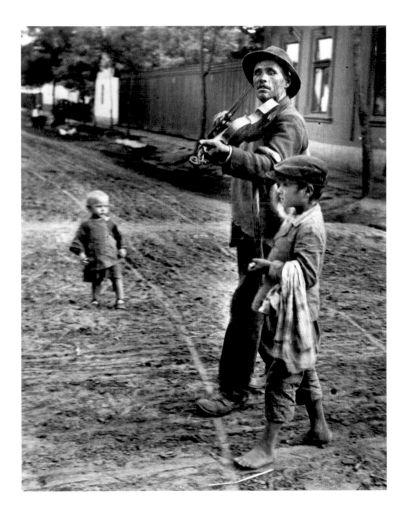

PLATE 8

Rue Vavin, Paris
1925

Gelatin silver print
24.1 x 19.4 cm
86.XM.706.31

During the summer of 1925, at the age of
thirty-one, Kertész became restless in Buda-
pest. Filled with self-assurance after seeing
one of his photographs reproduced on
the cover of *Erdekes Ujsag,* an illustrated
Hungarian magazine, he decided that art
was his true calling and persuaded his
mother to let him move to Paris, where he
had the ambition of becoming an artist-
photographer. When he arrived there he
registered at a small hotel on the rue Vavin.
He recalled this picture as being the first
he made in Paris, and one that established
the oblique viewpoint as his hallmark.
Kertész avoided planar, frontal composi-
tions—which he associated with the
documentary aesthetic—in favor of seeing
his subjects from the unexpected angles
that were highly personal to him.

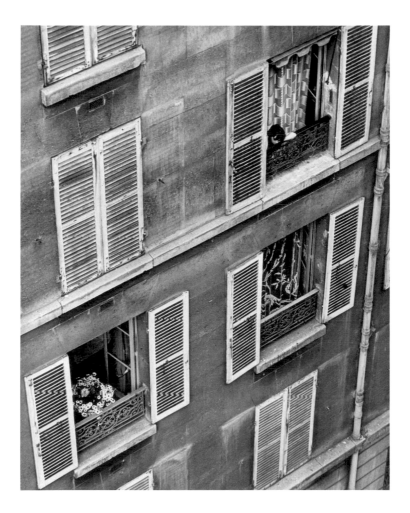

PLATE 9

Fountain in the Place
de la Concorde

1925

Gelatin silver print
5.2 x 3.8 cm
86.XM.706.1

In 1925, the year Kertész arrived in Paris,
the architect Le Corbusier (1887-1965)
published a utopian design for Paris—the
Plan voisin—a vision of the city with
colonies of glass skyscrapers. Kertész was
not interested in the city's potential for
radical restructuring but rather in the grace
and elegance of its existing monuments.
He was gifted at isolating details from
tourist monuments that express poetic
charm. However, within two years Kertész
would become heavily influenced by
Le Corbusier's movement *L'Esprit nouveau*
and find himself included in the publica-
tion of that name.

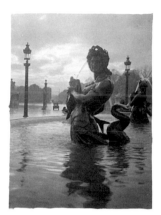

PLATE 10

Pont Louis-Philippe, Paris

1925–26

Gelatin silver print
5.2 x 3.8 cm
86.XM.706.3

Kertész persisted in focusing on traditional
subjects handled with poetic, but still con-
servative, techniques, such as the preceding
image; yet he also looked toward the future,
handling his compositions in more dar-
ing ways, as here. In this river study we see
neither a grand bridge nor a particularly
notable type of boat. Rather, the photogra-
pher is working with another variant on the
theme of the oblique viewpoint. The direc-
tion of the bridge establishes one element of
the compositional geometry, while a more
delicate and inferred direction is established
by the lines of the skiffs. The frame of his
viewfinder cuts through the background,
foreground, and edges at apparently
arbitrary points, thus denying to our eyes
the whole of any compositional element.

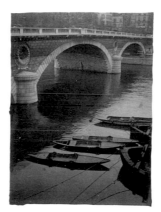

PLATE 11

Chimneys, Paris

1926–27

Gelatin silver print
5.6 x 6.2 cm
86.XM.706.2

Modernism and romanticism were mutually
exclusive attitudes for most artists of the
1920s. Yet holding such contradictory ideas
was one of Kertész's key traits. Photograph-
ing at dusk as he did in the *Eiffel Tower
at Night* (pl. 12) was an inherently romantic
decision. Here the Constructivist forms
of six chimneys and a derrick are raw but
elegant elements standing in contrast
to the tender humanism of the single lighted
window.

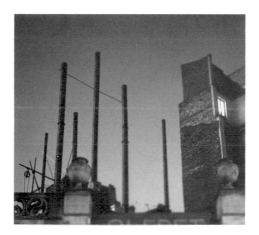

PLATE 12

Eiffel Tower at Night, Paris

1927

Gelatin silver print
7.9 x 10.4 cm
86.XM.706.13

Kertész's immigration card for entry
into France lists his occupation as *photo-
graphique réimprimer,* "photographic
printer"—a darkroom technician. Photo-
graphs dating from this period show him to
be a masterful printer. Although there are
no documents to prove it, Kertész may have
earned his living at first from darkroom
work, which in later years he came to loathe.
Photographers ranging from Stieglitz (who
wrote to a friend of his amazement at "how
'postal card' paper could be turned into such
beauty!") to Josef Sudek (1896–1976) used
carte postale paper for contact prints such
as this study, seen from a distant viewpoint.
Kertész succeeds in coaxing details from
the barely lighted foreground while still
retaining the delicate atmosphere of the sky.
Far from being a tourist view, this deeply
subjective study is rich in atmosphere.

Paris 1972

PLATE 13

Primel, France

1927

Gelatin silver print
4.4 x 7.8 cm
86.XM.706.16

In Hungary, Kertész appears to have rarely
photographed in and around the cities. He
also made few studies of picturesque sites
seen from highly personal vantage points,
such as he took in Paris. Rather, he devoted
himself almost exclusively to investigating
typical aspects of the Hungarian country-
side. This photograph has much in common
with *Wine Cellars at Budafok* (pl. 4) in the
bird's-eye viewpoint, the vernacular geome-
try of the haystacks, and the miniaturized
figures captured in the light in the course of
a day's work.

PLATE 14

Self-Portrait

1970s gelatin silver print
from a 1927 negative
20.3 x 19.7 cm
84.XM.193.34

Kertész had a powerful sense of self, which
he expressed in many self-portraits. He
began taking them while still a teenager and
continued making images of himself over
seventy years. Kertész has said that all of
his photographs are self-portraits, which is
indirectly true not just of him but of all
poet-photographers. For these special indi-
viduals, each photograph is a reflection
of their consciousness. We see here a per-
fectly recognizable profile as a shadow
on the wall. We also see the geometric out-
line of his tripod-mounted camera, which
was designed to expose glass plates measur-
ing four-and-a-half by six centimeters.

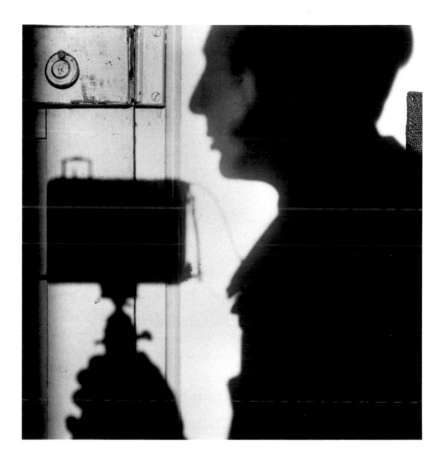

PLATE 15

Jean Slivinsky, Herwarth Walden, and Friends at Au Sacre du Printemps, Paris

1927

Gelatin silver print
8 x 10.9 cm
86.XM.706.7

Kertész loved the indirect self-portrait,
where his presence is no more than a dema-
terialized shadow on the wall (pl. 14). The
first exhibition of his photographs took
place at Jean Slivinsky's Au Sacre du
Printemps cafe, where people involved with
the new magazine *L'Esprit nouveau* gath-
ered. Slivinsky (center) is photographed
here with Herwarth Walden, director of the
gallery and magazine *Der Sturm* in Berlin,
and friends. Eight Kertész photographs—
including two of Kertész's classic images,
Mondrian's Pipe and Glasses and *Chez Mon-
drian* (pl. 17)—form the bottom row of pic-
tures. They are surrounded by other Kertész
photographs and the small, nonobjective
paintings of Ida Thal.

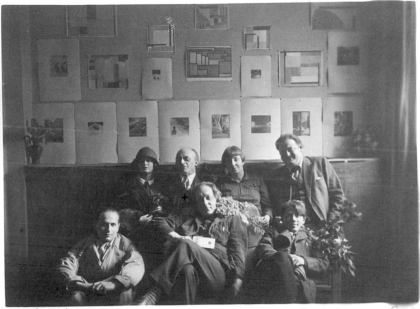

PLATE 16

Piet Mondrian, Paris
1926

Gelatin silver print
13.3 x 7.8 cm
93.XM.21.1

Kertész first visited the studio of Piet
Mondrian (1872–1944) in 1926 and com-
menced a series of photographs represent-
ing his artist friends and their studio
environments (pls. 17, 19, 22–25, 34). His
acquaintance with Mondrian appears to
have been Kertész's first personal experi-
ence with an artist who was part of the
main current of European Modernism. After
seeing Mondrian's art, Kertész suddenly
began to create spare and structured
photographs as he allowed the Formalism
first glimpsed in *Wine Cellars at Budafok*
(pl. 4) to dominate.

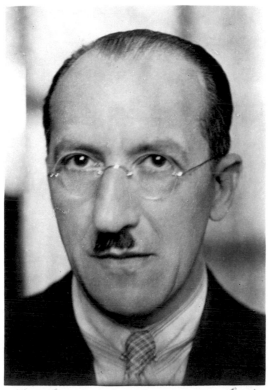

PLATE 17

Chez Mondrian, Paris
1926

Gelatin silver print
10.9 x 7.9 cm
86.XM.706.10

When Kertész arrived there in September
1925, Paris had been the world capital of art
for fifty years. Mondrian's genius was rec-
ognized and his work was being collected
seriously. "I went to his studio and instinc-
tively tried to capture in my photographs
the spirit of his paintings," Kertész said to a
friend. "He simplified, simplified, simpli-
fied. The studio with its symmetry dictated
the composition. He had a vase with a
flower, but the flower was artificial. It was
colored by him to match the studio," he
recalled decades later.

Kertész Paris

PLATE 18
Magda Förstner, Paris
1926

Gelatin silver print
10.9 x 5.9 cm
85.XM.371.1

PLATE 19
Anna-Marie Merkel [Mme Repsz], Paris
1927

1930s gelatin silver print
10.1 x 7.3 cm
86.XM.706.14

PLATE 20
Mrs. Hubbell, Paris
1931

Gelatin silver print
22.9 x 16.8 cm
84.XM.193.56

In the year he met Mondrian, Kertész became acquainted with an aspiring actress and cabaret singer named Magda Förstner. She was also his model for the celebrated *Satiric Dancer.* We see here a woman who could be expressing ecstasy. About this series Kertész recalled, "People in motion are wonderful to photograph. It means catching the right moment—the moment when one thing changes into something else."

Anna-Marie Merkel was an artist from Berlin who, along with Kertész, was a habitué of the Café du Dôme in Montparnasse. She was one of several women he photographed in 1927. Each was recorded with almost adoring respect.

In all his portraits Kertész paid close attention to the positioning of the sitter's hands, using them as expressive compositional elements. In this photograph of a Mrs. Hubbel, her thumb brushes the middle joint of her index finger, a gesture that reinforces her sensual gaze. This photograph was part of a project in which ten photographers portrayed the same model for the German magazine *Photo* (1931, no. 4); a version by Germaine Krull (1897–1985) also survives.

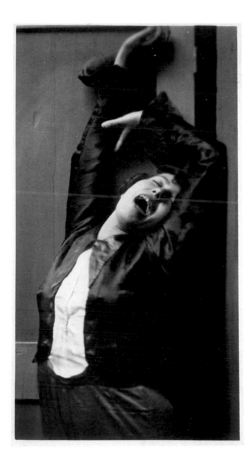

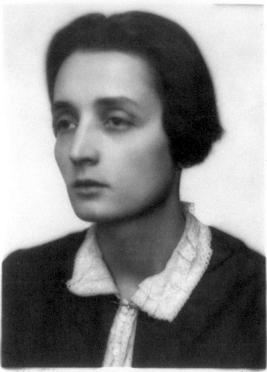

PLATE 21

Siamese Cat, Paris

1928

1930s gelatin silver print
17.4 x 15.9 cm
86.XM.706.41

In 1928 Kertész's style was moving to new
levels of sophistication. Far from sentimen-
tal, this strong portrait is comparable to
the formal austerity of the animal pictures
of Albert Renger-Patzsch (1897–1966).
This image may also relate to his series
of individual female portraits dating from
1927 and 1928. The Siamese cat, Nicholas
Dinky, belonged to the critic Florent Fels,
editor of the art magazine *L'Art vivant*.

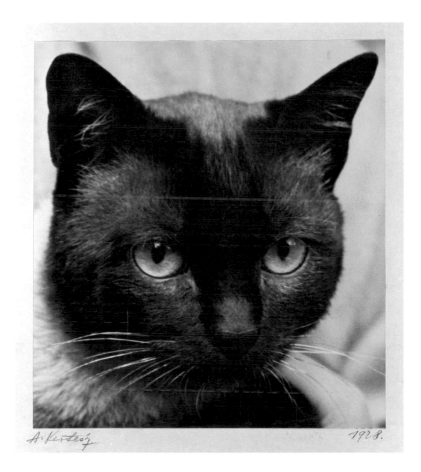

A. Kertész 1928.

PLATE 22

Peggy Rosskam, Paris

1927

Gelatin silver print
5.4 x 7.1 cm
86.XM.706.12

PLATE 23

**Edwin and Peggy
Rosskam and Friends,
Paris**

1927

Gelatin silver print
10.9 x 7.2 cm
85.XM.371.2

Edwin Rosskam, a writer and photographer
(b. 1903), lived with his wife, Peggy, and
their two Siamese cats in an apartment
designed by Le Corbusier. Kertész, who was
introduced to the Rosskams by Jean Slivin-
sky (holding their cat Perles), had very few
American friends in Paris and had unfavor-
able memories of visiting Gertrude Stein's
apartment about the time this picture was
made. His discomfort with Americans may
have been expressed in his uncharacteristic
use of the harsh, single-source lighting in
this study of Peggy with her cats. Kertész
preferred soft natural light for his portraits,
and the studies he made of Peggy and Edwin
Rosskam are exceptions to this rule.

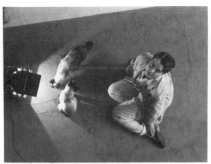

A. Kertész Paris

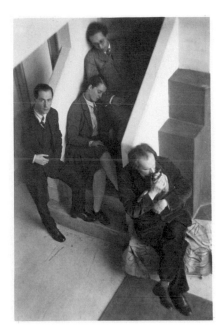

PLATE 24

Jean Lurçat, Paris
1927

1930s gelatin silver print
22.2 x 14.4 cm
85.XM.259.12

PLATE 25

Studio of Jean Lurçat, Paris
1927

1930s gelatin silver print
17.9 x 23.9 cm
85.XM.259.11

During Kertész's first three or four years in Paris, one force that maximized his aesthetic growth was the general influence of the artists he met, such as Jean Lurçat (1892–1966). He recalled that his portraits of artists were not made on assignment for the variety of illustrated publications that bought his photographs (*Le Sourire, Variétés, Le Matin, Kolnische Illustrierte Zeitung, Berliner Illustrierte Zeitung, Das Illustrierte Blatt,* and others). In these portraits he seems to be asking and trying to answer for himself the question What is an artist? Though he had no formal art school training himself, Kertész no doubt had begun to understand that he, too, was one of this elusive breed.

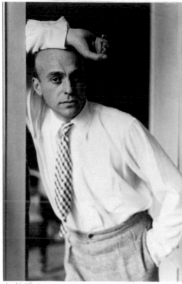

PLATE 26

Still Life, Paris

1926

Gelatin silver print
9.3 x 7.8 cm
86.XM.614.3

By 1926 Kertész had become acutely con-
scious of the visual arts beyond photography.
This awareness was manifested in his pic-
tures of interiors of artists' studios (pls. 17,
25) and some still life studies, such as this
arrangement of a wine glass, a half-full
bottle of mineral water, a Hungarian news-
paper, and a bowl of overripe bananas. Still
life for Kertész was an homage to the com-
pletely manual process that he strongly
identified with art. This picture, made in
his apartment, also records his minimal
personal needs.

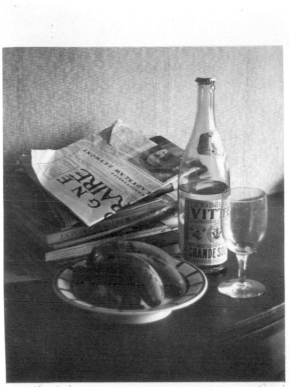

A Kertész Paris

PLATE 27

**Hands and Books,
Paris**
1927

Gelatin silver print
9.5 x 5.7 cm
86.XM.706.11

During 1926 and 1927, Kertész seems to
have been wrestling with issues posed by
nature in its relation to the machine. Here
we find these elements juxtaposed. The
sharp edges and uniform dimensions of
the books are brought into visual harmony
with a pair of hands.

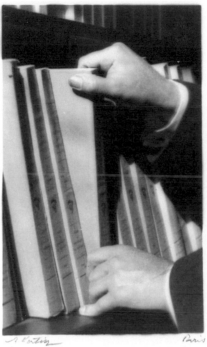

A. Kertész Paris

PLATE 28

Study of People and
Shadows, Paris

1928

1930s gelatin silver print
15.8 x 22 cm
84.XP.909.1

Still lifes took a variety of forms for Kertész.
Some of them he carefully arranged, such
as *Hands and Books* (pl. 27), while others
he photographed unaltered, such as this
arrangement of figures seen from the stair-
well of his apartment at 5, rue de Vanves.
Here the choice of viewpoint is the key
artistic decision.

PLATE 29

From the Eiffel Tower, Paris

1970s gelatin silver print
from a 1929 negative
19.6 x 24.6 cm
84.XM.193.17

Kertész made several studies of the Eiffel
Tower as a freestanding object (pl. 12) soon
after arriving in Paris in 1925. By 1929
the oblique viewpoint had begun to domi-
nate his vision. The subject here is the
diffused shadows of the ironwork and of
the pedestrians at the base of the tower.

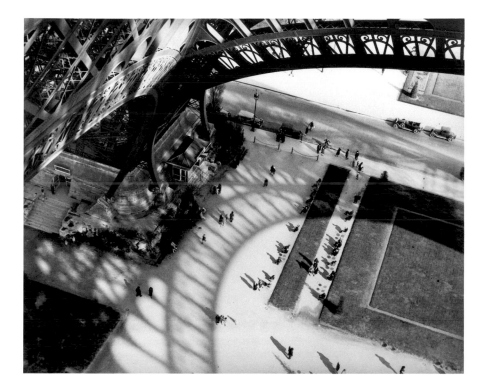

PLATE 30

Meudon, France

1970s gelatin silver print
from a 1928 negative
24.7 x 17.3 cm
84.XM.193.14

The harnessing of time, space, and motion
is the photographer's objective here; the
forces in motion are a locomotive in the
background and a man holding a large par-
cel wrapped in newspapers who is in
mid-stride and headed toward the camera.
The train will continue to its destination;
the man will complete his errand, ignorant
that he has been part of a notable instant—
the creation of a work of art that will greatly
outlive the actuality represented. Taken
with a new Leica, the photograph is a per-
fect illustration of how this camera made
possible for Kertész the spontaneous arrest
of fleeting situations.

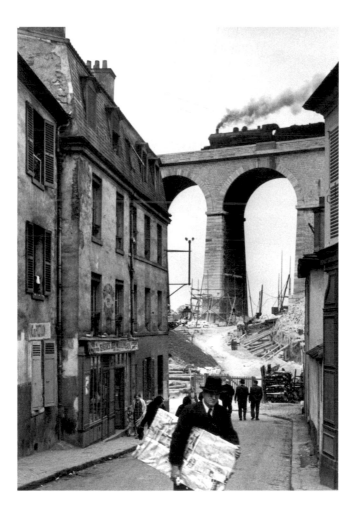

PLATE 31

Legs, Paris

1925

1930s gelatin silver print
22.7 x 13.5 cm
84.XM.193.43

PLATE 32

Artificial Leg, Paris

1927

1930s gelatin silver print
24.4 x 18.4 cm
86.XM.706.32

PLATE 33

Clayton "Peg Leg" Bates, Paris

1929

1930s gelatin silver print
23.8 x 18.1 cm
86.XM.706.38

Kertész was fascinated by decontextualized legs. This study (pl. 31) of the inverted lower half of a mannequin was created in a ramshackle studio where used mannequins were refurbished. This found still life reflects elements of Dadaism in the accidental gathering of unrelated elements that range from containers of various types to a suggestive piece of cord. Surrealism is evoked by the way in which an object—the mannequin—usually found in a pristine commercial context is shown in a messy and unexpected one.

The study of a prosthetic leg (pl. 32) was made in a hospice for homeless men. The unanswered questions here are: Why are there two beds with the same number? And where is the owner of the artificial limb in the foreground?

"Peg Leg" Bates (pl. 33) was a dancer who performed with an American jazz group that visited Paris in 1929. The other pictures in this series show Bates performing, while this photograph removes him completely from his public context to a completely private and aestheticized one.

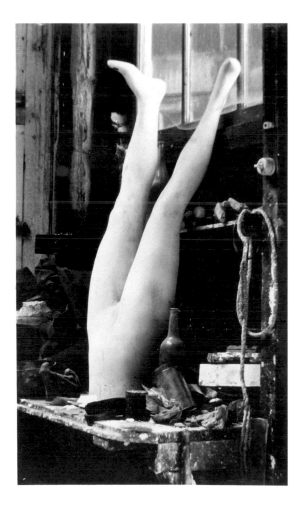

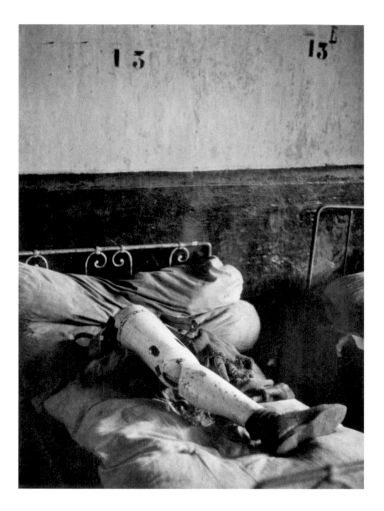

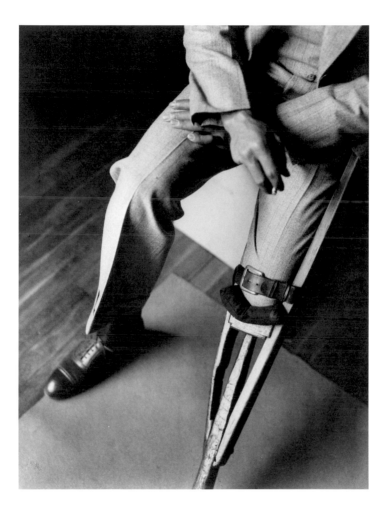

PLATE 34

Pierre Demaria, Paris
1929

1930s gelatin silver print
17.3 x 22.9 cm
84.XM.193.73

This photograph fits into Kertész's series of
studies of artists and their accouterments
(pls. 16–17, 22–25). The subject is an adver-
tising illustrator with a companion, each
helping to support a mirrored ball that
reflects an inverted image of the photogra-
pher with his camera and flash apparatus:
a self-portrait within a double portrait.

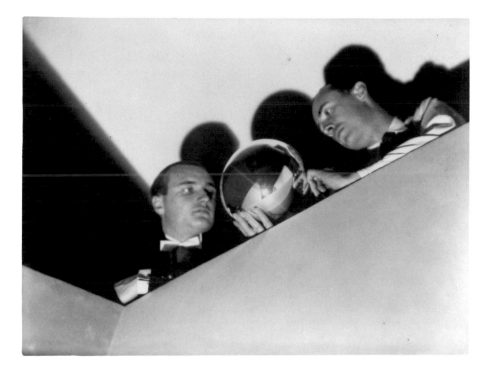

PLATE 35

The Harbor at Brest, France

1929

1930s gelatin silver print
22.4 x 16.5 cm
85.XM.259.8

The year this negative was made, 1929,
was the occasion of a landmark exhibition
in Stuttgart entitled *Film und Foto,* where
work by some of the most progressive
photographers in the world was gathered
together for the first time. Kertész was
represented by *Mondrian's Pipe and Glasses*
and *Hands and Books* (pl. 27). In that
exhibition were works by László Moholy-
Nagy (1895–1946) and Alexander
Rodchenko (1891–1956), who were exper-
imenting with ways to compose photo-
graphs looking down from towers, bridges,
and viaducts. Kertész had done the same
with cityscape and landscape subjects
such as *Wine Cellars at Budafok* (pl. 4).
While visiting Brest he photographed this
industrial-maritime composition, a new
subject in his work.

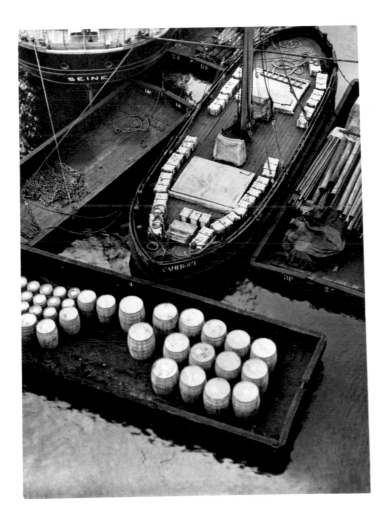

PLATE 36

Clock of the Académie
Française, Paris

1950s gelatin silver print
from a 1929/32 negative
25.1 x 19.7 cm
84.XM.193.1

By the early 1930s Kertész was able to earn
his livelihood by making photographs
with highly personal visual stories for pub-
lication in picture magazines. He generated
the ideas for these by prospecting for
subjects around Paris. One day he charmed
his way into the non-public parts of the
venerable Académie Française, where
he discovered abandoned attic rooms filled
with graffiti and other strange sights. He
photographed it all and sold the story to a
Dutch magazine. When the academy ad-
ministrators learned of the plan to publish
the pictures, they cleaned the attic, painted
out the graffiti, and denied the existence
of the place. All the public ever saw was this
mysterious picture taken from the cupola,
looking across the river Seine over the
Pont des Arts to the Louvre, through the
transparent face of the academy clock.

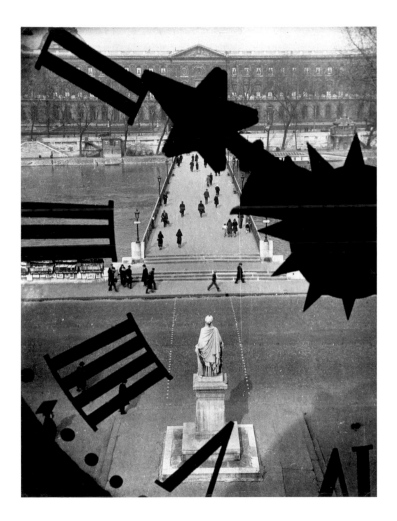

PLATE 37

Distortion Number 40, Paris

1970s gelatin silver print
from a 1933 negative
18.9 x 24.7 cm
84.XM.193.18

PLATE 38

Distortion Number 150, Paris

1970s gelatin silver print
from a 1933 negative
24.7 x 19.9 cm
85.XM.176.7

PLATE 39

Nude, Paris
Circa 1933

Gelatin silver print
23.1 x 9.5 cm
86.XM.706.33

The nature of womanhood began to pre-occupy Kertész in 1933 in a very different way than in his female portraits of 1927 (pls. 18–20): the early series presents perfectly costumed and coiffured women, while the 1933 series shows women in vulnerable and distorted states of undress.

Kertész was hired in 1933 by the men's magazine *Le Sourire* to create a series of nude studies using parabolic mirrors to exaggerate and condense different parts of the picture. The images show a direct connection to Surrealist painting and literature. Picasso also created grotesque transformations of the ideal female form during this period.

The third photograph is one of the few surviving undistorted studies of Kertész's model for the series of approximately two hundred Distortions. She stands in front of the mirror, with its edge tracing a background highlight from behind her head to behind her crotch and knees, as if to give some clue to the erotic element underlying all the Distortions.

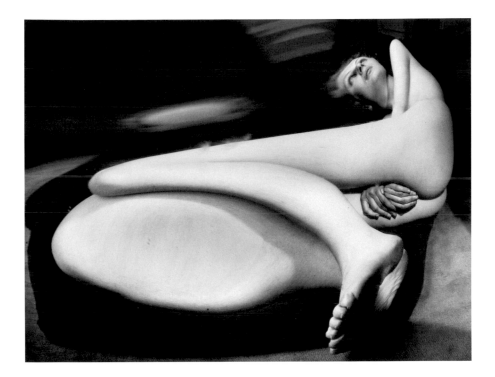

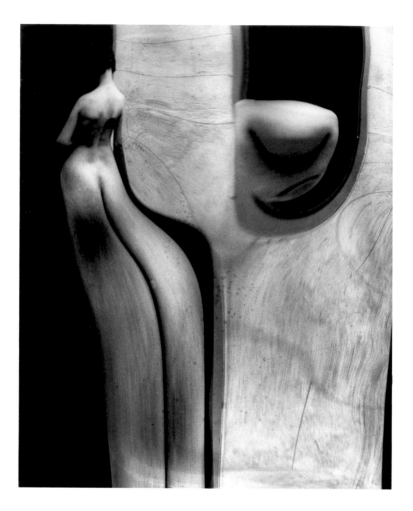

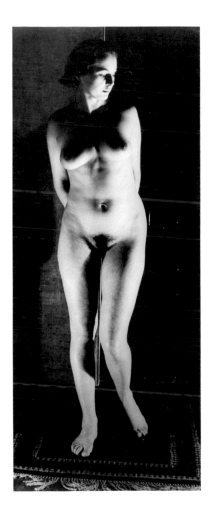

PLATE 41

Arm and Ventilator, New York

1937

Gelatin silver print
13.6 x 11.3 cm
85.XM.259.15

When Kertész and his wife Elizabeth arrived
in New York by steamer from France on
October 15, 1936, the forces of Fascism
were growing in Europe and the worst of
the Great Depression was not yet over
in the United States. Kertész spent his time
prowling the streets looking for typical sub-
jects, just as he had when he first arrived
in Paris a decade earlier. The ventilator
here belongs to a drugstore located at Fifth
Avenue and Eighth Street in Greenwich
Village. A repairman is at work replacing a
part; however, only his arm shows. This
photograph poses the same question asked
by *Artificial Leg* (pl. 32): Where is the owner
of the limb?

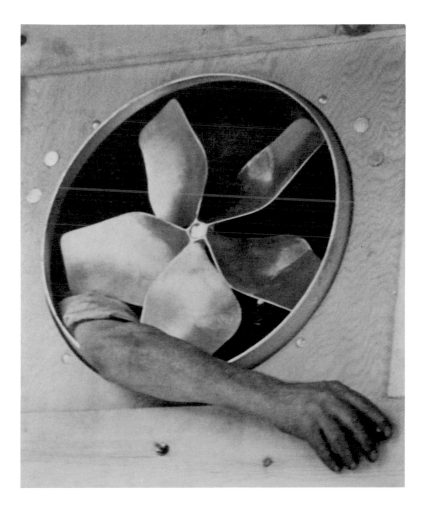

PLATE 42

The Lost Cloud,
New York

1937

1970s gelatin silver print
24.8 x 16.5 cm
84.XM.193.13

Nineteen thirty-seven in New York was al-
most as productive for Kertész as 1926 had
been in Paris. It was a time of elation and
despair, a time of discovery and of process-
ing those discoveries through his own
consciousness. Kertész observed a solitary
white cloud lost in a huge blue sky and
dwarfed by a monolithic skyscraper. He once
said that the cloud represented himself—
something without control over its own
destiny and subject to the prevailing winds.
Rockefeller Center stood for America—
a fortress that he as a newly arrived immi-
grant felt helpless to penetrate.

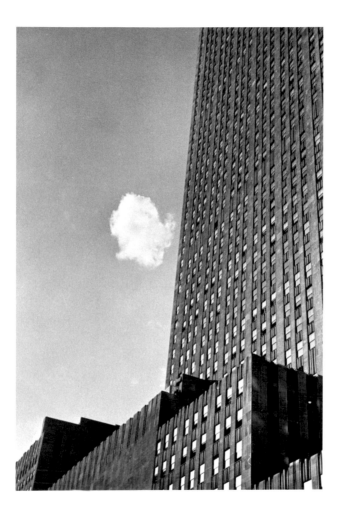

PLATE 43

Skywriting, New York

1938

Gelatin silver print
24.5 x 18.9 cm
86.XM.706.21

Not long after Kertész made *The Lost Cloud*
(pl. 42), another opportunity to photograph
an ephemeral cloud presented itself at
almost the same location. Letters of the al-
phabet have been inscribed in the air, but
unlike *The Lost Cloud* their scale is larger
than the Rockefeller Center building nearby,
giving the photograph a humorous touch.
The letters are upside down from Kertész's
viewpoint; in place of despair, the mood
here is playful.

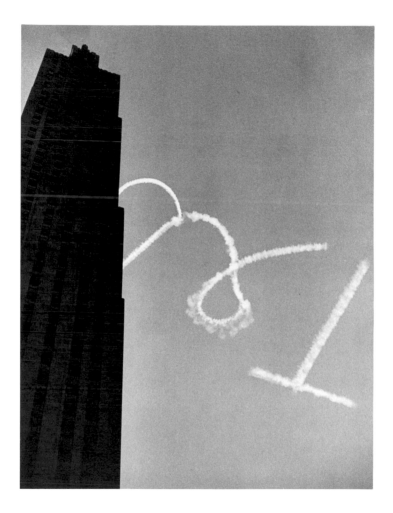

PLATE 44

Melancholic Tulip,
New York

1970s gelatin silver print
from a February 10, 1939,
negative
24.7 x 17.7 cm
84.XM.193.9

In New York, Kertész returned to a practice
he had begun back in Hungary of inscribing
the exact date of each exposure on the pro-
tective sleeve of the negative. We know that
this picture was made on February 10, 1939.
This is a time of year when melancholy
moods strike even normally happy and pro-
ductive natures, and they struck Kertész
particularly hard. Using a parabolic mirror
that he had brought from Paris, Kertész
created a distorted still life that is also a
self-portrait of the artist as a wilted flower.

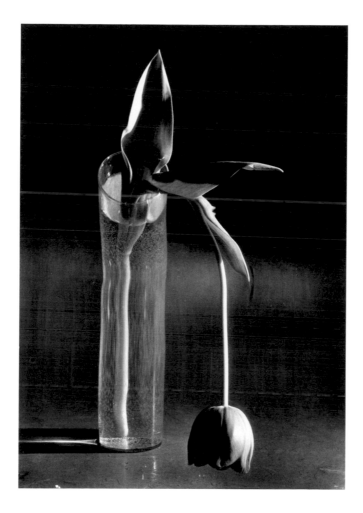

PLATE 45

Pilings;
Weehawken,
New Jersey
1941

Gelatin silver print
19.4 x 15.6 cm
86.XM.706.24

When he arrived in the United States in 1936, Kertész was hoping to get work as a photojournalist with a picture magazine, such as the newly established *Life.* In 1939 he was invited by the magazine to prepare a personal report on New York City, focusing on its waterfront. The editors decided not to print the photographs, thereby fore-closing the artist's future association with the publication.

This photograph is marked with a profoundly melancholy mood despite its Formalist, even Constructivist elements, which are usually anti-emotional in picture language. It is one of the last photographs Kertész made before the status of enemy alien was imposed on him by the entry of the United States into World War II.

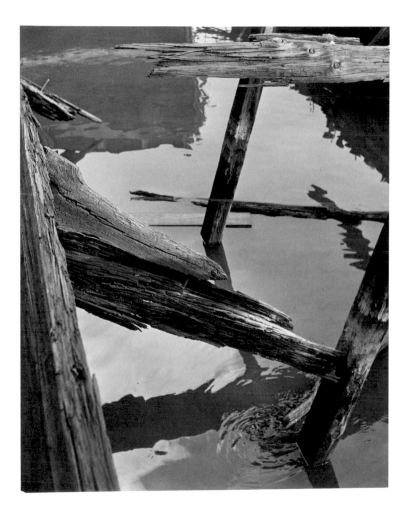

PLATE 46

Relaxation [Sari Dienes], New York
1943

Gelatin silver print
19.2 x 23.7 cm
84.XM.193.51

Between 1941, when the United States en-
tered World War II, and the surrender of
Japan in 1945, Kertész was proscribed from
photographing on his most productive
terrain, the streets of New York, because his
Hungarian nationality made him an enemy
alien. When he did take pictures during
these years, it was to record a moment
of private pleasure, such as this image of a
friend sunbathing on the roof of her hus-
band's Union Square studio. Sari Dienes was
the wife of the painter Paul Dienes, who
had collected Kertész's distorted nudes as
reference studies for his paintings.

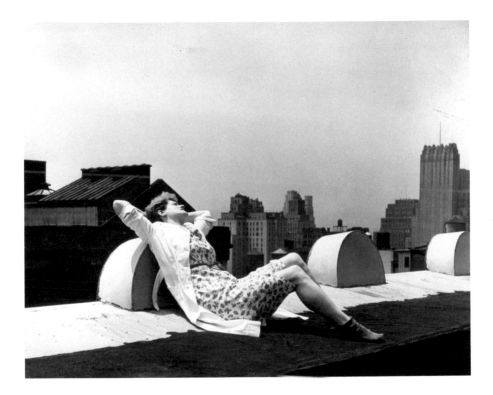

PLATE 47

Watchmaker's Shop, Christopher Street, New York

1970s gelatin silver print
from a 1950 negative
24.7 x 16.4 cm
84.XM.193.15

Time is a major part of the content of
every photograph, since every photograph
records a specific instant and every photo-
graph may be used as a gauge of time's
passage. Kertész photographed clocks on
several occasions, most notably the clock of
the Académie Française in Paris, seen
from inside the cupola where it was housed
(pl. 36). Here we see a clock marking pre-
cisely two minutes and a few seconds
after two p.m. The long shadow of the figure
striding into the frame from the left indi-
cates that it was made in the late winter or
fall, when at two o'clock the sun is already
low in the sky.

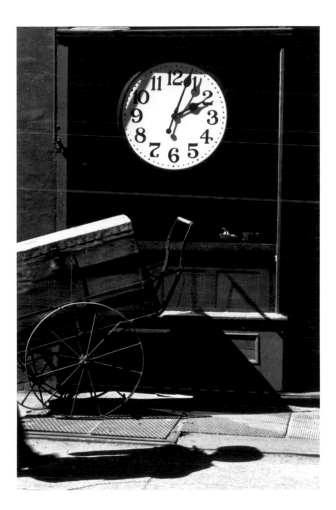

PLATE 48

Going for a Walk,
New York
1958

Gelatin silver print
34.3 x 26.8 cm
86.XM.706.26

Creating still life arrangements was an
activity that Kertész began in Paris (pls. 17,
26) and continued in a limited way in
New York. Starting in 1946 he was employed
full time by *House and Garden* magazine.
This arrangement is quite literally a self-
portrait because of the envelope addressed
to the photographer. The headline on the
clipping, "Going for a Walk," describes how
Kertész wished he could be spending his
time instead of being shackled to the routine
assignments of his editors.

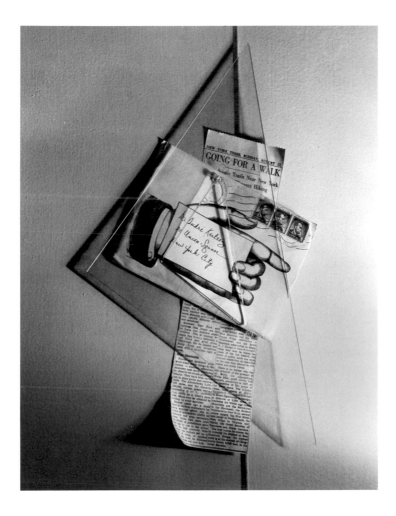

PLATE 49

The Broken Bench,
New York

1970s gelatin silver print
from a September 20, 1962,
negative
17 x 24.7 cm
84.XM.193.19

Frank Thomas (Ferenç Tamas), the figure
with his back to the camera here, was
a friend of the Kertészes in Paris. After he
emigrated to the United States in 1937,
he became Elizabeth's partner in a cosmet-
ics manufacturing enterprise that was quite
successful and became the chief source
of their income after 1962. Thomas lost his
eyesight, was abandoned by his wife, and
came to depend on the Kertészes for most of
his needs. This photograph was taken
when he accompanied them on an outing to
visit another friend, who had been insti-
tutionalized. In the background, seated on a
bench, are Elizabeth and the young woman,
who also relied on the Kertészes for support.
Kertész composed this portrait of his ex-
tended family quite deliberately. It is full of
symbolic meaning, but—aside from its
title—the photographer has provided few
clues to its interpretation.

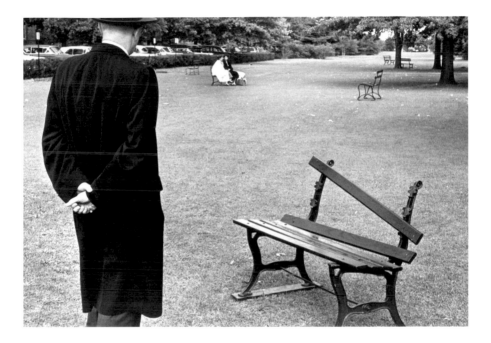

PLATE 50

Broken Plate, Paris

1970s gelatin silver print
from a 1929 negative
19.3 x 24.7 cm
84.XM.193.39

When Kertész left Paris for New York in
1936, he left behind most of the negatives he
had created there. They were entrusted
to the care of a woman who had been one
of his editors. Unbeknownst to him, she had
removed them to her country house in
the south of France for safekeeping during
the war. While testing a new lens in Paris in
1929, he had gazed out the window and
made this exposure, which was quite unre-
markable until it was damaged while in the
custody of his French friend. This negative,
with its bullet-hole-like fracture, was
returned to him in 1963, along with other
negatives, damaged and undamaged, that he
had completely forgotten. He discarded
all the broken ones except this. "An accident
helped me to produce a beautiful effect,"
he remarked. Even though the negative was
made decades earlier, this photograph
represents Kertész's style of the late 1960s
and early 1970s.

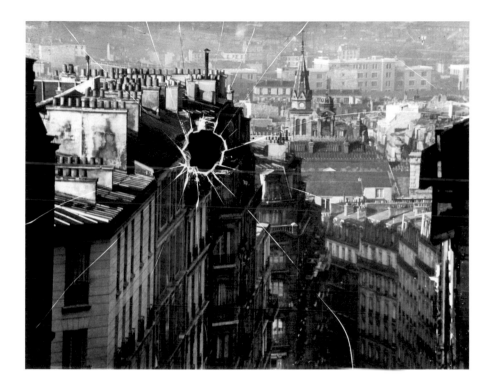

PLATE 51

Elizabeth, Paris

1970s gelatin silver print
from a 1931 negative
24.7 x 18.8 cm
84.XM.193.38

Kertész's marriage to Rosza-Joséphine Klein
had been dissolved by 1931. In that year
he asked his sweetheart back in Budapest,
Erezsebet Salomon (later Elizabeth Saly),
to join him in Paris. Soon after her arrival
he created a double portrait, with her
gazing directly into the camera and him
looking adoringly at her with his head
turned in near-profile. Forty years later he
returned to the negative and printed it
in the radically altered version we see here.
Elizabeth's face is cut in half through
the nose, and Kertész is gone except for the
right hand that affectionately grasps her
shoulder. The new composition relates to
the radical rethinking of his earlier work
that occurred in the early 1970s, at about the
same time that he first realized the value
of *Broken Plate* (pl. 50).

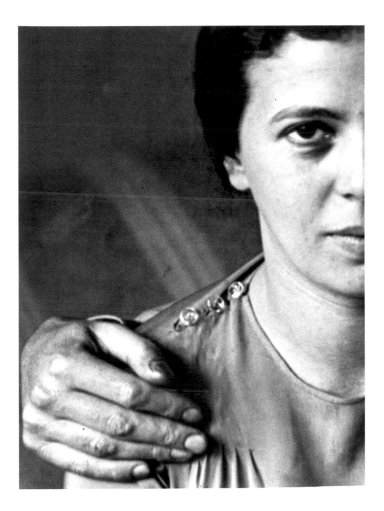

PLATE 52

Puddle, New York

1970s gelatin silver print
from a September 17, 1967,
negative
24.7 x 16.7 cm
84.XM.193.41

On a rainy late summer day in 1967, Kertész
was enjoying the fifth year of his freedom
from the routine chores at *House and
Garden.* On his way to visit his Hungarian
friend, the photographer Cornell Capa
(b. 1918), who lived practically across the
street from the Empire State Building, he
took this photograph. Kertész was delighted
to see that the tallest building in the world
could be dematerialized and turned upside
down through a reflection in a puddle. His
business with Capa was to agree to partici-
pate in an exhibition that would take him to
Japan for the first time a year later (pl. 53).

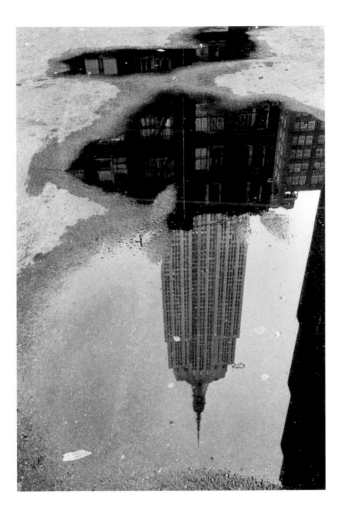

PLATE 53

Rainy Day, Tokyo

1970s gelatin silver print
from a September 14, 1968,
negative
24.7 x 13.7 cm
84.XM.193.20

Almost a year to the day after he photo-
graphed the Empire State Building in a pud-
dle (pl. 52), Kertész experienced another
rainy day while visiting Tokyo. Gazing
from his hotel room, he observed an orderly
line of Japanese office workers with
seemingly identical black umbrellas, all
oblivious to the relationship between them
and the traffic arrow—a relationship that
accident and chance had called into being.

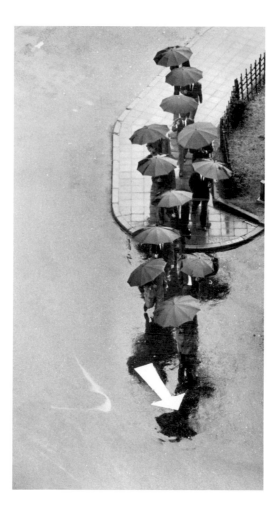

PLATE 54

Martinique

January 1, 1972

Gelatin silver print
19.2 x 24.7 cm
84.XM.193.21

Kertész and his wife were on vacation
on the island of Martinique in the Lesser
Antilles when he took this picture. They
shared a balcony with the adjacent hotel
room. He immediately made some unsuc-
cessful attempts to compose a picture
utilizing the glass partition of the balcony
and incorporating boats passing on the
horizon. On New Year's Day, a French-
speaking family moved into the adjacent
room. The mother, father, and children
took turns occupying a position at the rail-
ing on their balcony, producing a diffuse
shadow on Kertész's side. Full of suggestive
human content, this photograph is
built around a solidly Formalist vision.

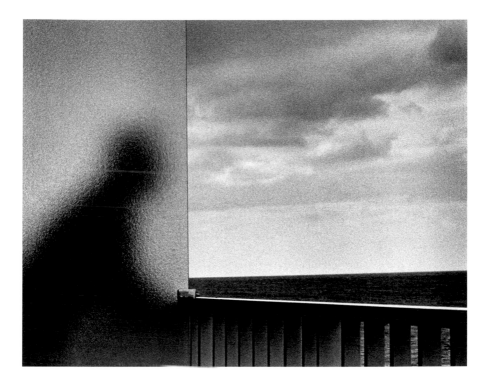

Sylvia Plachy. *André Kertész*, 1974.
Gelatin silver print, 15.8 x 23.2 cm.
© 1993 Sylvia Plachy.

André Kertész:
An Intimate View

Charles Hagen: A good place to start a discussion of any photographer's life and work is probably with some photographs. We thought we'd begin by looking at several of Kertész's early images. The first one, the overview of Budafok (pl. 4), is actually of wine cellars near the village. He took this in 1919 while he was still living in Budapest working in the stock exchange. To me it expresses a very auto-biographical side of his work. I see the central drama of it being the young man walking away behind the first row of houses into a strange, almost magical land-scape, while the mother waits in the courtyard, watching him leave.

Weston Naef: This is one of the first photographs in which Kertész pulls back from his subject and waits, like a hunter stalking game, for the perfect, telling moment. Each of those figures suggests that something—we are expected to imag-ine what—will happen in the future. And, although they are still, these figures animate the photograph. We see here the seeds of a type of picture that Kertész made later in Paris and New York. So for me, this particular picture foretells much of his future work, and I find it seminal.

David Travis: Hungary is a country of villages, like most of Eastern Europe. If Kertész had grown up in the village and were to make a photograph of it, he might not have gotten as far away as he has here. But coming from Budapest, he is able to look at the village as a whole, with the scope of a novel.

Robert Gurbo: I've always seen this image as representing a set of choices that André had at the time, of leaving or staying. Maybe that person walking away is André on the journey. Or maybe he sees himself as being planted, like the man sitting in the foreground. He sets up these choices, and he contemplates them. In the background is the next village, lit up by the sun, and it's as if he is contemplating going off into the distance, into the future.

WN: Where was he standing to make this? It's a bird's-eye view, which isn't easy to achieve. Was he on a hill? Was he in a building, or a church tower?

DT: He was on a hill.

WN: That's what we've often heard. But it must have been a very steep hill, because we're looking almost straight down, or else he had some way of zeroing in on the subject. Of course, the power to zoom in on the subject is something that became important for Kertész later, when the zoom lens was invented.

We're also seeing a group of very geometrical buildings, and yet their geometry seems to relate not to provincial life but to all the things that we know about the coming of the Machine Age. These rustic geometries connect with machine forms; he uses the buildings as the armature of the picture.

CH: The magical, dreamlike quality of this picture is due in part to those houses, which are farm houses and barns—but are also archetypal house shapes. They are what a child would draw. I am also interested in the way he focuses attention on the boy walking away, with the arch of the doorway creating a halo around him. It's a very rich image. Did Kertész tell a story about how he made this picture?

Sylvia Plachy: Not to me. But to follow up on what David said, he lived in the city and came to the country on weekends. It occurs to me that I have never seen pictures of his parents or his life in Budapest. The only ones of his brothers are when they had escaped the strictness of home and were running around naked in the forest like satyrs—really in their element. Kertész had to leave home in order to be anything, because he didn't really fit in there. His entire life was like that. He was caught in this conflict of having a bourgeois background, which was very constrictive in Eastern Europe—and still is to some degree—and wanting to be an artist from very early on. In order to be an artist, he had to go to Paris or some

other place. He was happy when he was a soldier and had been wounded, because then he could roam freely and not have to work.

DT: This brings up his role as a refugee, an outsider. At one point that was liberating for him, but later it ceased to be.

SP: That's very true. It was both liberating and difficult.

WN: André told me, "People always ask me about this picture." He said that for him it was first of all a picture of wine cellars. The contents of these buildings were as interesting to him as their exteriors.

 I remember him saying "I can't explain this picture in an analytical way. I don't know what it means to me, but it means a lot." This set a recurring theme in our meetings—his professing not to be able to explain his pictures and saying that he acted purely on instinct. And yet, this picture raises a question that comes back to me often in his work: Did he find these people the way we see them, or did he pose them? Again and again he shows us subjects that are so perfectly arranged they seem planned. The mystery is whether he found these subjects or has staged them, like he did with his brother in *The Dancing Faun* (pl. 5), about which he remarked, "I asked my brother to express a scherzo."

SP: Whenever he was on the street, he was just looking, and his whole idea was to wait for and be aware of these magic things that happen for an instant. He loved to arrange still lifes; that was his other side. But I don't think he would have staged this whole scene.

CH: The issues that we are bringing up in terms of this picture are probably applicable to almost any of his photographs. So let's go on to *Underwater Swimmer* (pl. 3), made in Esztergom in 1917.

WN: This picture is remarkable to me because it appears to be a totally private moment. I imagine Kertész in direct and isolated communication with the swimmer. Yet André told me that this was not the case, that he was seated in a tier of benches surrounding the public swimming pool with his military comrades, who were undergoing physical therapy, as was the man swimming. We have to look carefully at the picture to unravel what we're seeing. At first glance it looks like a figure diving.

Kertész told me that one of the ways he made friends was to photograph the other soldiers with their girlfriends from the local village. He would chuckle and say, "They couldn't understand why I was photographing a man undergoing physical therapy, and teased me."

The question in my mind is, When did he first recognize the greatness of the picture? Did he realize it when he made the negative or when he moved to Paris in the twenties and was first exposed to Modernism? Or was it only when his Hungarian negatives were returned to him in New York in 1962, almost fifty years after the negative was made?

RG: From what we can piece together, it seems that this photograph first surfaced in New York. The earliest print I know of is from around 1937 or '38, a glossy 11 x 14 that might have been printed in Paris as part of a portfolio that he was taking to New York. It still has some of the quality of the printing he did in Paris. I don't know of any images of the *Swimmer* reproduced while he was still in Paris.

DT: Well, we are speculating that the negative may have remained in Hungary when he went to Paris in 1925, and that he retrieved it only when he returned to Budapest before moving to New York. He went back in 1933 or so, when his mother died, and at that point he may have collected all his things, realizing that he might never return. He moved to New York only three years later. And in fact, from 1933 to '36 in Paris, he didn't publish a lot in the magazines, so the negative may have sat in a box until he got to New York.

CH: It is a very rich picture, obviously. We can figure out how it was done. But the picture is really not about a soldier undergoing therapy. It's about a figure floating through space, a very ambiguous space. The legs seem to be above water while everything else seems to be under.

RG: But you don't see the transitions.

CH: No, you can't find the edge of the water at all. And the interplay of the light patterns on the bottom of the pool with the shadows on the figure and even the striped trunks is fascinating. This picture suggests a Chagall to me, with a figure floating over a night landscape.

RG: I find it hard to believe that he didn't recognize this as one of his more powerful images when he made it. Its magical quality, the way the light constantly changes because of the water movement, is evident in both the negative and the contact print, so he must have had an inkling of what a great picture it was. But it must have been an image that surprised him as it came up in the developing tray.

The slide we're looking at is from a contemporary print, made in the eighties, where he chose to crop about an eighth of the top and left-hand side of the image. In the original, your eye can stray from what he has chosen for us to look at here, and it loses some of its mystery, because you're given a point of reference.

WN: It's important to think about this as a work that may have been created fifty years after the negative was exposed, when Kertész was living in New York. The magic of this picture for me is that the instant of making the negative was one of action, an action that took place fifty years before the contemplation occurred— the contemplation that caused him to create this cropping of the picture.

RG: When do you see this image as being completed?

WN: I see it as being completed essentially when it was presented in his book *Sixty Years* [New York, 1972]. So far as I know, that was its first widespread reproduction. Let's take a great painting, such as James Ensor's *Christ's Entry into Brussels in 1889*, in the Getty. This was a public work from the day Ensor began painting it; anyone who visited his studio could see that he was working on a monumental piece. It inspired expectations. A photographer, on the other hand, can have a major work—such as this picture—be totally latent for decades, existing only as a negative that he must return to and elaborate and make public.

CH: With most of Kertész's pictures, and certainly with these early Hungarian pictures, it is important to document when they were first seen and first acknowledged.

DT: *Satiric Dancer* was not published right away. That's another picture that became famous only later, when photography itself was gaining its public.

CH: There's a strong sense of Kertész going back and reunderstanding some of the things he had done as a young man. David, you've spoken of negatives as being like a scientist's data, which he goes back and analyzes and brings a pattern to—in this case, some sort of emotional understanding.

DT: Photographers do that more than other artists, I think. Another analogy I can think of is writing a poem that gets buried in an unpublished manuscript. To make this image would have taken a small part of an afternoon; you could forget that you took it. Photography is one of the few arts where you find this. It allows people to go back, not only to rediscover themselves but also to get something in print for the first time.

SP: You take a picture, but later you might forget it. You discover it again on the contact sheet, but then maybe you forget it again before you print it. And so the process goes on through many oblivions and layers, until finally, hopefully, the real gems are pulled out and saved from the depths of your unconscious.

Don't forget, too, that in Hungary André didn't have the audience that he had later on. When he went to Paris, he had to earn a living, which he did by making photo stories. So he was probably concentrating more on things that he could publish. He wasn't showing in galleries, because they didn't exist.

RG: Well, he was not in the circle of the Surrealists, who might have recognized the power of this.

DT: If this picture had been firmly attached to a meaning at the time, it might have been difficult to resurrect later, except as a historical record about Hungary and World War I. But now it's a swimmer, and we can call it a diver, and we can call it a recuperating soldier—it can take on all these possible meanings.

SP: It goes beyond the moment and has a life of its own, and that's its beauty. But I think it is also representational. The body looks corroded and crumpled. André too had been wounded, so perhaps he looked at this image and saw himself slightly mangled and yet still able to fly.

CH: One of the essential strengths of photography is that it's about the world, but it's also about our emotional and psychological understandings of the world. It's about fantasies, too.

114

SP: It's a lot about fantasies, and that's why he was a photographer, I think.

RG: Did he bring the negative with him to New York in 1936, or did he retrieve it in 1962, when he brought back his negatives from Paris?

DT: If he got it in 1962, that would have been the perfect time to rediscover it, because at that point he was about to reinvent himself. He had basically retired, so he was going to be a photographer on his terms.

WN: We can't forget that in 1962 he was sixty-eight years old. By then he had lived what most people think of as the bulk of their productive lives.

SP: Right. And that's when you start thinking of your childhood, thinking of Hungary and when you were born and all of that. There were some early pictures that he did not have negatives for, so he made copy negatives from the prints, and that's the only thing that exists. There were glass negatives that were broken or lost in the mail.

WN: One of them is *Broken Plate* (pl. 50); it also brings up something I meant to say about *Underwater Swimmer* (pl. 3): just as there are painters' painters, André always seemed to me a photographer's photographer, even though he also had a wide audience. The story of this picture has been repeated often. A book I'm reading called *Kertész on Kertész* [New York, 1985] says: "In this picture of Montmartre, I was just testing a new lens for a special effect. When I went to America, I left most of my material in Paris, and when I returned, I found sixty percent of the glass plate negatives were broken. This one I saved, but it had a hole in it. I printed it anyway. An accident helped me produce a beautiful effect."

RG: He claimed that there were hundreds of broken glass plates, and this was the only one that surfaced.

DT: He must have been crushed when he found them all damaged. But he did have a way of working himself out of bad situations. He had that kind of luck, and the temperament, to find a bit of twinkle in something like that.

WN: Was the picture printed from the original glass plate, or did he create a replica negative? In the reproduction we see a negative that is in many fragments. In order to print it, he had to piece it together and stabilize it in some way.

RG: The modern print of this image was probably made from a copy negative. The original was intact when I saw it—it was not broken through to the edges. I vaguely remember black tape around it.

DT: How many copy negatives were there?

RG: He had copy negatives made of his important images, also of all the Distortions. When these negatives were restored, copy negatives were made in case the restoration had any side effects. My understanding, though, is that the modern prints were made from the originals and the copy negative was held in reserve in case the original was destroyed. This was the case whenever I printed for him.

CH: What I find marvelous about this picture is that in it Kertész has found a way to bring out the metaphor of the photograph as a memory. He's obviously pointing out the physical substance of the image and how fragmentary it is. In doing so he takes it one step further; with that black hole it becomes like *Martinique* (pl. 54), where there is deep emptiness, a vast space. Beyond the physical world, beyond memory, there is a void.

RG: Also, the negative was shattered by the war. It was moved to a bomb shelter outside Paris by a friend. In crates with the other negatives and correspondence he left behind when he came to New York, it was left to freeze in the winter and warm up in the summer, over and over again for twenty-seven years.

DT: The picture is a happy result of the tragedy of the negatives.

SP: He dealt with similar situations his entire life. He was wounded in World War I, and the happy result of that was that he became a photographer. He took every bad situation and turned it into something good. When you think about his life—or the life of anybody living in Europe during that time—you realize how difficult it was; those two wars and the losses from them shaped him and affected his pictures.

RG: What you said about him having to face bad situations, being wounded or, here, dealing with his negative being destroyed, brings up the later image of him as a bitter, negative person. When I first met André, we spent six months

battling over who he was. I refused to believe that he was miserable, because I believed his photographs.

SP: I had the same experience.

WN: Sylvia, you told me once about spending time with André under very different circumstances, watching television.

SP: Oh, you love that story! I met André about twenty years before he died, when I was in college. My teacher sent me to see him because he thought that our pictures had similar sensibilities, and both of us were Hungarian. I'd visit him whenever I was in the neighborhood, and we became good friends. He told me that he considered himself my adoptive grandfather, which made me very happy, because I didn't have a grandfather—I lost one in World War I and the other in World War II. I started working at the *Village Voice,* which was only a few blocks away from his apartment, in 1974. The paper went to bed on Monday nights and sometimes we would stay quite late. So I would call André about nine and ask to come up for tea. A few times he was watching wrestling on television, and he left it on when I came in. He'd sit me down and I would say, "Wrestling?" "Yes," he'd say, "Watch! You can learn from anything." And he believed it. I would say: "You know this isn't real, it's set up." "No!" he'd disagree. "I watch this guy in the American costume all the time. He is not faking."

CH: We've been talking about Kertész as an older man looking back to his youth in Hungary. But when he first went to Paris in 1925 he was obviously looking forward, facing the future rather than the past. But his Paris pictures have the same quality of loneliness as his later works.

DT: Well, that's the way he was. He wasn't reminiscing all the time. When he looked at the future, he was a lonely man. There are solitary figures in his Paris pictures, so this symbolism is easy to read. But generally, they are very tidy, well-ordered still lifes and Paris scenes. I think that has to do with his being alone out there and simplifying things. He has an interest not just in abstraction but in a clarity that is a result of concentrating—and that goes hand in hand with solitude.

WN: But the joie de vivre that we think of as part of Paris life does not come through in the pictures. His is a rather melancholy spirit. There's nothing so ebullient and light-hearted as, say, a Hungarian picture like *Lovers* (pl. 1) or the two gypsy children kissing. In Hungary he focused on overt manifestations of human affection. In Paris there is always a kind of distance.

SP: He picked a lot of overviews, bird's-eye views. He not only photographed pigeons but he also took pictures from their vantage point.

DT: But that also goes with the idea that a photographer has a privileged view, can sneak up into places where other people have never been. Everyone who lives in tall buildings sees them, but not as pictures—only as experiences.

SP: It must have been very difficult for him to come to New York, considering that he was forty-two or so when he arrived. That's why he had so much anger.

DT: If he had come here a few years later, during the war, he might have had a very different attitude about this country.

SP: Right. But he never saw that this was really a haven for him, that all sorts of horrors might have befallen him had he stayed in his beloved Paris. The other source of his anger here was money. He would say "that son-of-a-bitch America." He would tell me that the god of America was money.

DT: André didn't do badly in Paris. He had German publishers who paid two or three times what the French publishers paid. But when he came to this country, he must have felt it was really about money.

SP: Money and power. He didn't realize how much of a struggle it would be.

DT: Also, he was in Paris when the illustrated magazines were just starting. If you look through those magazines, you see that photographers had much more input about content in the early years, in 1928 or '29. But very soon the editors re-alized that there had to be an art director and an assignment editor if the maga-zines were to come out weekly—they couldn't wait for a photographer to get a spectacular story. So the power shifted very quickly.

WN: When he came to the United States he was not plugged into the power structure at all. He had no friends here. He was a hired hand, an assignment photographer. In 1936 he believed that he should be on the *Life* magazine team, but when he tried out for it he was rejected, and ended up with *Look*. André was mortally offended at not having been selected for the A-team at *Life*. Had he been at *Life*, the history of photojournalism might have been different. He would have added a humanistic leavening and a bohemian sensibility that *Life* needed badly. And he might have become a very different person had he been given that opportunity. He wouldn't have built up two decades of hostility and suppressed creativity.

But then perhaps we would have been deprived of his extraordinary late work, of the sequence of pictures that leads from *Lost Cloud* (pl. 42) to *Broken Plate* (fig. 50) and then *Melancholic Tulip* (pl. 44). Here is a picture, made at the height of his rejection in this country, where he is the tulip—he is the wilted flower.

DT: Well, we might not have those. But what would we have in their place?

WN: If he had been working for *Life*, they would have gotten him security clearance during the war. Instead, because he was an outsider, he could make no pictures between 1940 and 1945. For five years he had to work secretly.

DT: But the other side of it is that he would have been beholden to Henry Luce and the editors. That would have been a tough one for him.

RG: My sense is that in the magazines at the time photographers had to prove themselves. André had a certain arrogance; he didn't want to jump through hoops anymore. He became frustrated, indignant. He didn't get the jobs, or when he did, he would become angry at how his pictures were used.

DT: At this time, was his wife's perfume business flourishing? Because he could've had some freedom if they had had another source of income.

RG: His family photographs, the snapshots from 1940 through the 1970s, depict a very bourgeois life—the country house in Connecticut, the grand piano in his apartment. Everything suggests that they lived life to its fullest, and it was all

based on Elizabeth's money. I don't know how successful her perfume company was in the thirties, but certainly prior to the time when we came to know him, she was supporting him.

SP: None of us saw Elizabeth in the way that he did, but I always felt that perhaps she was the kind of person he needed—practical and down-to-earth. He could be this floating photographer with her grounding. There may have been difficulties in the relationship, but at the same time there was a basic pull—he really did love her.

DT: The classic picture is the portrait of Elizabeth (pl. 51).

WN: Yes, the often-reproduced portrait of Elizabeth with her face bisected and his hand on her shoulder. It's a picture that presents many puzzles. First of all, he has literally defaced her and eliminated himself from the relationship. The picture was first published as a double portrait, showing André looking adoringly at Elizabeth, who is dark-haired, dark-eyed, purse-lipped, a strong-willed woman who yet somehow has gentle features. He spoke of her with deep affection and much later hoped to publish a book devoted exclusively to pictures of her. But there seems to be a contradiction between the way she actually was and the way he made her seem.

CH: There are interesting anomalies in the relationship. He took those sweet early pictures of her in Hungary, but then fifteen years elapsed before they got back together in Paris. And there's his first marriage, which he didn't talk about.

DT: He pretended it never happened. I remember Sandra Phillips asked him who Rosza Klein—his first wife—was and André said, "I think she was a photographer in Paris."

RG: That marriage didn't fit into his myth of who he was. He had this image of himself and Elizabeth falling in love as a young boy and girl in Budapest. He moves to Paris, establishes himself, and she joins him later. Then together they move to New York. There are a number of images of Elizabeth in the archive that piece together the puzzle of who she was and what their relationship was, but what he chose to show us was the myth. I was there the day after what I call the

Day of Wrath—when he first saw Sandra Phillips's manuscript for *Of Paris and New York* [Chicago and New York, 1985], where she spelled out the whole story of that first marriage. He was full of pure rage. André always had a problem when reality interfered with his myth. After all, he was living it out, much of it must have become fact to him.

DT: The question is one of biography. We know an enormous amount about the lives of most of the artists of our time who reached the same degree of celebrity as Kertész. What is surprising and even shocking is how little is known about some of our greatest photographers.

CH: I think it's fascinating how many photographers chose pseudonyms in that period. Robert and Cornell Capa, Brassaï, Chim, Izis. There's a sense almost of becoming a photographer as a way of reinventing yourself.

SP: Well, yes, but sometimes a name change may have had to do with anti-Semitism in Europe. Even after the war, or perhaps especially then, fear prevailed. It affected André and many other people.

CH: But there was a sense, I think, in the twenties and thirties, of artists inventing a new world. It was possible to break with your roots, to leave your home in Czechoslovakia or Poland or elsewhere and go to Berlin or Paris, or to come here.

SP: Not only was it possible, it was often necessary to leave those countries to become an artist. It was provincial there, you felt stifled; you had to learn a skill and make a living, you had to be very dutiful, you had to fit in. To be an artist was only possible for aristocrats, and they were out of business after World War I. And later, during Communism, artists had to follow the party line and make Socialist Realist statues or other propaganda. That is why to be an artist you had to leave, both then and earlier.

WN: André never made it clear to anyone exactly why he left Paris for New York, except that he experienced some great threat. Whenever I asked him about his beliefs (using the word in its broadest sense), he never said that he was raised Jewish. He always said that he believed there was only one God and that

we were all being watched over by that God. Yet it's clear, from the papers that were made available after he died, that Kertész was raised and educated in the Jewish tradition. His schoolbooks, for example, have Hebrew writing on them, and his youthful poetry is the kind of writing that young Jewish boys were asked to write in order to manifest their spiritual side. This must have influenced him greatly, because there is a strong connection between the photographs and poetry.

DT: Would André have gone to New York if Elizabeth had refused to go? It would have been hard for him. So she must have agreed to go.

DT: He had an invitation to come to New York, according to him. But it must have been a mutual decision. Certainly the reason they never went back to Paris was because she couldn't take her business there.

WN: André wanted us to believe that he left Europe because he was threatened, that he came to this country because he had to, and that when he got here he took the best job he could find, working for Keystone as a photographer for hire, where he wasn't even credited when the work was printed. He wanted us to think of this as a unilateral decision. He came here with a few dollars and a suitcase and his talent, hoped to make good, but was scorned. The truth of the matter is probably closer to what David is suggesting.

DT: His arrival in Paris was quite different. In *Of Paris and New York*, Sandra Phillips writes: "One early evening in September 1925 André Kertész stepped off the train from Budapest and entered Paris for the first time. He carried with him a Hungarian peasant flute, his cameras, and the money that he had carefully saved to permit him a year or two of freedom to find his way as a photographer. For the first night, and for several that followed, Kertész stayed in a small hotel on the rue Vavin, not far from the Montparnasse station. When he awoke, he leaned out of his window and took his first photograph of Paris, a city he had been long-ing to see for perhaps ten years." The picture, *Rue Vavin* (pl. 8), looks very cropped. But if you were to get in a narrow Parisian street and look across, this is about how close you would be with a normal lens. It could almost be a poster ad-vertising Paris, not a landscape, but a detail. And it must have been not only what

he saw but also what he imagined. Paris is a more crowded city than Budapest, but people are leaning out of windows with flowers.

CH: It's also a Modernist picture, in that it's seen from above; it's strongly geometric. And as always, he humanizes a Modernist image by having this narrative of the woman looking at the flowers.

DT: Yes. Then, as Sandra points out in her essay, he goes on foot and takes pictures more like what you might expect someone to take wandering around Paris—a view of the Seine, Notre Dame at night. But they are not just images he is going to send to his mother to say, "Look, this is Notre Dame!" They are his own discoveries—his personal views.

CH: How much did he know about Modernism when he came to Paris, and how much did he learn while he was there? If this was his first picture, it seems pretty advanced.

DT: Well, he would probably have seen Modernist images in Hungary. But if you judge just from what he made in Hungary, you see it's mixed still. You could say that the building was so close that the picture had to be like that; to get the flowers in at all, he would have had to take it at an angle. But there would have been a hundred other ways to take this to make it look conventional.

WN: I've always thought of this picture as a miracle, based on the myth that this was the first picture he took in Paris. If it was, how could it be so perfect? There are two versions, one with a little girl in the window and one with an older woman. The fact that there are two studies is important, because already he is acting as the hunter, the stalker. He is not merely yawning, looking out the window and snapping the first thing he sees, as the myth suggests, but patiently surveying a scene that changes during the course of the day, and seizing on that change. How long does it take for the young girl to be replaced by the older woman? It must have been hours. Because the process of whiling away the time, which is what we're seeing, evolves very slowly during the day.

DT: It's the perfect note to begin a new career on. And in fact, it's not impossible that other pictures might have preceded it and been discarded or reversed in his

mind as being absolutely first. I'm willing to believe that it's his first one, on his word. But if you placed this six months later, in 1926, it would fit right in.

WN: Other pictures from this period relate to the Kertész we know well from the Hungarian pictures. But this seems like the obverse of the view of Budafok that we talked about. *Wine Cellars at Budafok* (pl. 4) has geometric elements, but it's panoramic. Here he moves in as though to take a detail of the Budafok image.

DT: But there are sometimes surprises in Pictorial photography that start to become more geometric and look almost Modernistic. The rigidity of this geometry suggests something else. But this isn't too many steps from a Pictorialist idea. You could imagine a Pictorialist standing next to him, adjusting the camera slightly, and coming up with a perfectly good salon print.

WN: What I find extraordinary about this is the ambivalence, a feeling of not being able to decide between the multitude of subjects before him. There are two windows, with two very interesting subjects that he refuses to choose between, even though he tells us he had a primitive zoom lens and therefore could have zoomed in.

RG: If you assume that he did not have the zoom lens, it might be the fact that the building was very close and the camera limited what he could do. Once Cornell Capa asked him about the Budafok picture, "How did you make this photograph so geometric?" and André answered, "The subject was geometric." There are glimpses of that geometric vision all through his earlier work.

DT: In an enlargement, you have the option to crop, essentially making it a telephoto picture, because the view provided by a telephoto lens is an enlargement of a scene. So this might be like *Underwater Swimmer* (pl. 3). There might be only a little more in the negative, and the picture is slightly enlarged, or it could easily be that everything is so small you don't see the subject until he enlarges it.

CH: It's also interesting psychologically. You've got the protagonist trying to get to the flowers—and she can't.

WN: I wonder if there's anything deeper in this picture. We know how André responded when he arrived in New York, because he told us. But we know how he

felt when he arrived in Paris only through the pictures. Looking here particularly at the *Rue Vavin* picture (pl. 8), I notice that it is about windows with open and closed shutters—two windows with their shutters closed flanked by three windows with their shutters open. And in each of the windows with open shutters, there is a welcoming presence. He is, once again, an outsider looking in, confronted with the perennial issue of open and closed doors. When we talk about how optimistic he was when he arrived in Paris, we can say that the statistics here are on the side of the open windows.

CH: And to head off in a different direction, you've got the flowers, both the real flowers and the fake flowers printed on the curtains. If you see this as a choice—something Robert brought up with the *Wine Cellars at Budafok* (pl. 4) panorama—the choice here is between the image and reality.

WN: Is it correct for us to ask what his intentions were here—to try to guess what the artist buried instinctively within the picture?

CH: There is also the question that came up with the early Hungarian pictures: When did he become aware of their significance? With some pictures, he probably knew when he took them—*Martinique* (pl. 54), for example. But with others, he didn't even print them until the fifties or sixties.

WN: We know this was used in *Day of Paris* [New York, 1945], which is the key document for determining when he first recognized which pictures were notable. There are pictures in *Day of Paris* that I am continually astonished to find there and others that were not included but have since become celebrated.

RG: It is a book with a program; there is an editorial overlay. As with the book *Paris Vu par André Kertész* [Paris, 1934], there was an editor at work.

DT: How much any book is the editor's statement and how much it is the photographer's is an interesting question. Before this time there hadn't been many books that were the photographer's statement.

WN: To go back to the picture itself: how studied is it? He told us he was not an analytical photographer, but this picture seems very analytical. He previsualized the picture and worked carefully to get it.

CH: I would argue that this picture can serve different purposes, as in fact all photographs can. It can be seen as a typically charming view of Paris or read in a more interesting psychological way. So the question recurs, Was he aware at the time he put this in his Paris book of it being anything more than a pretty picture?

WN: My answer is yes, because of the way it is presented in the book, next to another view of the same scene, with an older woman in one of the windows. The two are arranged on a spread, so they seem almost to be one picture.

CH: We think of Kertész as being a great innovator of street photography. Were there other people at this time doing anything similar?

WN: There weren't many. It was really in Germany where Paul Wolf and others used miniature, or 35-millimeter, cameras first.

DT: There was a whole flock of journalists who used larger portable cameras, and you can often see them in German magazines. But the lyrical idea of a picture like this comes from an amateur's yearnings to picture something, which is perfectly connected with Kertész's experience. And he did it so well.

CH: To what extent do you think Kertész's vision at this point is being shaped by the markets that he works for—the fact that he is taking pictures for magazines?

DT: Well, he only starts to work for magazines in 1928 or so. For two years in Paris he is pretty free. A lot of the pictures that exist from that time were taken walking around Paris, and a lot are portraits of his friends and people he was introduced to. And then you get studio visits to people he doesn't know—Léger, Chagall. I think he took these to get the pictures published. But he was also very interested in characterizing the people by finding still lifes in their studios that would be meaningful in relation to their art.

WN: I find it quite interesting that in 1923 and '24 Kertész was being published in Hungarian newspapers and magazines, photo magazines in particular. But when I thumbed through the two or three that we have, I was astonished that it wasn't easy to pick out the Kertész photographs—they all look like Kertész! They are very general, lots of street views, but not views that are pregnant with social information.

DT: In Budapest his vision hadn't quite crystallized; he was interested in journalistic items and Pictorialism.

WN: What about André's sense of himself in Paris? We have here what is to me an iconic picture, *Self-Portrait* from 1927 (pl. 14), of his shadow against the wall with the profile of a camera.

DT: It's very different from most of the things he did at the time.

WN: His work from Paris that we admire most is either of the streets or the studio interiors; generally the portraits don't seem so compelling. And yet he made some surprising self-portraits, one after another.

Charles spoke of photography as a medium that allows a photographer to continuously invent and reinvent himself or herself. And I continue to return to these self-portraits, because Kertész seems to be shouting at us through them, "I am in the process of inventing myself!"

RG: I relate the shadow self-portrait to *Martinique* (pl. 54), done much later, where he toyed with letting out the dark side of himself, as he did with *Melancholic Tulip* (pl. 44).

WN: I am reminded of one of my favorites among the Paris pictures that also depends on shadows for its effect—the study from the Eiffel Tower (pl. 29), looking down at the courtyard below, where the subject is all shadows and silhouettes.

DT: Well, in photography, a shadow is just a form. The arrangement of that picture is marvelous. But Emile Zola took a picture looking down as well, and you could imagine any number of tourists taking pictures from that angle. Kertész's genius is that he makes an asymmetrical composition of it. The street's tilted; he could have straightened it out, but the composition would have been more rigid.

The wonderful thing about the tower is that it has this decorative, nonfunctional curve, added to create an elegance to its whole sweep. When you look at the tower, it's made of straight girders, but nothing in it looks straight. That arch keeps it from seeming totally rigid. But here the part of the tower that didn't need to be there is the whole picture for André.

WN: The *Self-Portrait* (pl. 14) is so much like a Bauhaus picture—it's completely flattened, like a collage. The strength of this view is how full it is of space, but a space that we couldn't conveniently inhabit the way he photographs it.

CH: This picture exemplifies the somewhat ambivalent position Kertész had towards Modernism. It's really a Constructivist view, with the dynamic diagonal, the overhead view looking down, and the play of shadows. It can be seen as a typical scene of Paris, meant to be sold to magazines, but also as a Modernist formal invention. It reminds me of two other pictures: Alvin Langdon Coburn's *Octopus* [1912], which also looks down from a tower, and Moholy-Nagy's *Radio Tower: Berlin* [1928]. They represent two opposite approaches to this same motif— Kertész being somewhere in the middle, with a French flavor.

WN: Well, the French definitely leaned toward Pictorialism rather than Modernism. And here I would point specifically to the soft-focus quality that the shadow of the metal tracery has on the ground.

SP: Do you remember how many Eiffel Tower paperweights André had all over his apartment?

WN: Yes. That was an icon for him—perhaps of his later travels there, when he bought them as tourist objects.

CH: What about Kertész's relationships with women in this period? In the Paris years, he made the Distortions; he also was married twice.

DT: As I understand it, the Distortions (pls. 37–38) came about at the suggestion of an editor at *Le Sourire*, a humor magazine that was on the risqué side. They would commission artists to write or create illustrations, and this was the first idea using photography. André had done pictures involving distortions; the picture of the fortuneteller in the glass ball, for example, and in 1930 or earlier he had made a distorted portrait. So to do that with nudes would have been a natural idea.

WN: Kertész told me that he was commissioned to make these pictures by a man named Monsieur Querelle, the editor of the magazine, who also procured the two models. One was a teenage girl and the other was older, and he began to explore the contrasts between the two women as part of the unfolding experiment. The

older woman was a former cabaret dancer and had some connection to Magda, the model for *Satiric Dancer;* they may have worked at the same cabaret. He remembered vividly that he used two floodlights to illuminate the scenes. He ended up making 208 of these images.

To me, the interesting thing about the Distortions is his transition from a picture like the one on the announcement for his first exhibition, at the Galerie Au Sacre du Printemps, in which the expression of the woman is very provocative but the cross on her blouse seems almost symbolic. And all the women he photographed for portraits, those wonderful, stern, sometimes gentle women, are always seen from a distance, as though each one was a goddess. And then suddenly, he undresses a woman! For the first time since the Hungarian nude, the wonderful nude with her face covered.

DT: Once he said something about his portraits of women, and I misunderstood it at first. He said, "Look at the faces, they're the faces of middle-aged women." He meant "medieval faces," from the Middle Ages. And they do look like medieval faces—some of them are stone-faced.

WN: How intimately did he know the women he photographed for the portraits?

DT: They were often people who spoke Hungarian, acquaintances from his circle of friends. In the portraits there was almost always eye contact, but in the Distortions there is none. The Distortions project gave him a way to stare at the women, but it also allowed him a bit of distance, where he could invent the picture more imaginatively. In just eight sessions he invented all kinds of pictures from the device of the mirror.

CH: But the pictures themselves are never very sexually charged. He seems never to have been able to express his sexual attraction openly.

DT: He wasn't capable of using photography as a way to pick up girls—it was his art, a way to know people. He wasn't libidinous in that way; in fact, he was prudish.

CH: I find the contrast between Kertész's one posed nude (pl. 39) and the Distortions (pls. 37–38) very interesting. In the posed nude the woman looks like the Venus de Milo, while the Distortions are caricatures of women. These two are

combined in *Satiric Dancer*, where the statue is on the left-hand side of the frame and the woman is on the couch, distorted and openly alluring.

DT: In one of the Distortions the model is shown in the foreground, undistorted, but in the background she appears in the mirror, distorted. In this picture she is primary—which she's not in most of the other pictures. Pictures like that are particularly interesting, because they show how the mirror worked.

WN: Later he did other distortions—a martini glass, a darkroom timer, a cigarette package.

DT: Well, it is a funhouse idea. But also he made the pictures the year the Nazis came to power in Germany, when there was distress in Europe. You can also see in these pictures echoes of works by other artists—Picasso, Dalí, Henry Moore. His mother died that year, too. And Elizabeth had come to Paris from Budapest not that long before, in 1931. That may have caused stress as well.

WN: *Distortion Number 150* (pl. 38) is an astonishing picture. At the left side we see the standing figure with a minuscule head and enormous rounded buttocks and thighs that extend the entire length of the picture, and then, to the right, a form that looks like a marble Brancusi sculpture.

DT: Yes, with Henry Moore added.

WN: Sylvia, I can't resist asking what you think of André's attitude towards women, and of the Distortions and his portraits of women (pls. 18–20).

SP: I don't know many of his portraits of women. Someone once suggested that the Distortions gave him the freedom to be a voyeur, but I don't think those pictures were sexual.

DT: I agree. I think he adored women and kept his distance. Every nude he ever took was a purposeful thing. Roméo Martinez said that André was in fact a very good boy; he would go to bed early and then get up for assignments. He wasn't carousing all night. He had night photographs, but they weren't so much about people at night, the way Brassaï's are; they were about the lonely night.

WN: We know of his mother's importance in his life, through her affectionate letters and through symbols like the embroidered linen she sent him. And yet André married Elizabeth, who kept him in a kind of glass cage.

CH: Isn't it fascinating that he didn't marry her until after his mother died?

DT: Well, she came to Paris in 1931. Now, the question is, were they officially married at that point? It's not clear.

CH: In the crucial year of 1933—when he did the Distortions, when his mother died, when he may or may not have married Elizabeth—he also published in Paris his first book, *Enfants*, dedicated to both his mother and Elizabeth. That seems telling, a kind of passing of the torch.

SP: Another question that comes up is whether he was a Surrealist and whether being in Paris brought that out in him. That question intrigues me. I think that there was another source for his Surrealism, the kind Milan Kundera has. It's innate to the Eastern European mind, a kind of twisted way of looking at things.

DT: That picture of the upside-down legs in a studio (pl. 31) is inscribed something like, "This is what they are calling Surrealism." So he was aware of the movement, but he wasn't signing up for it. André was more of a Constructivist— if you want to make that dichotomy—than a Surrealist. But he is really neither. He invested a little in each.

WN: What he said to me, and I'm sure he said it to many people, was, "I am a Naturalist Surrealist."

CH: Does *Martinique* (pl. 54), which he took much later, fit into Kertész's Surrealistic strain?

SP: *Martinique* is definitely an extension of Magritte in some ways.

DT: I see it as representing a kind of concocted Realism. It's encountered, but you could imagine someone posing it.

RG: André had the ability to tap into all of these movements in art without becoming dogmatic about it. He would just borrow their style and incorporate it into his desire to express himself. The mix of styles would become his alone.

WN: For me, the most extraordinary antecedent for *Martinique* is *Rue Vavin* (pl. 8). For that picture, he says he was standing in his hotel room looking out at two windows with people moving in and out to give him different subjects. And that is precisely what he told me was happening in *Martinique*. He and Elizabeth had gone to Martinique after Christmas in 1971, and he made the picture on New Year's Day, 1972. The room next to them had been vacant, and then suddenly he began to hear voices speaking French. It was a family, a mother and father and two children, and they would move back and forth from the room to the balcony, creating different silhouettes against that frosted glass. So André said he poised himself on a deck chair, waited through the course of a day or two, and made three exposures—first, of one of the children; second, of an older person, a man; and third, with a boat, a steamer, off on the horizon. He rejected the others for one reason or another and finally settled on this one. But when I asked what it meant, he would never say, as he did about many other pictures, "That shadow is me."

RG: This picture frightens me. Many of André's pictures have a sadder, dark side. But almost always he gives you a way to escape from it, by allowing you to look at other details in the images: trees, streetlamps, patterns. With this particular image he does not give you an out.

CH: It makes me think of *Underwater Swimmer* (pl. 3), where you have the same kind of shadowy, distorted figure. There the figure is in the water; here it is an old man thinking about the water.

SP: The swimmer is in motion, in flight. Here the figure is like a rock—stuck, waiting for death.

DT: When I first saw this photograph, I didn't think it was so much about death. It went back and forth all the time, and I thought that was the marvel of it. It was the first picture of André's the Art Institute of Chicago bought. He loved that idea, that we bought his latest work and were going backward.

SP: That's how his career lasted as long as it did—he continually reinvented himself. Being a good photographer for so many years is a very hard thing to maintain, but in his work you can still find great pictures until the end. Some of

the Polaroids are also powerful, and *Martinique* (pl. 54) is as moving as anything from his youth.

WN: He was seventy-eight years old when he made this picture. When I saw this and realized that it was made by a man of that age, and the picture was so vigorous and youthful, it startled me.

RG: Compare what he has done with the water here with what he did in *Underwater Swimmer*. There, at the beginning of the journey, the figure is immersed, being battered and distorted as he travels through the water. Now, in *Martinique*, this person is removed from the journey, the water, contemplating the past. And the water is a hard surface, no longer penetrable.

Weston, could you explain how you see it as youthful?

WN: Youthful because a picture of this formal strength can only be made by someone in the prime of their physical and creative spirit. Youthful in the sense that it is totally conceived. There are none of the soft edges that old age brings. Take, for example, Edward Weston's last pictures, very murky studies of battered trees on the edge of the coastline, or Paul Strand's studies of flowers in the backyard of his house in France.

Until this conversation, I had never consciously thought of this picture as being sinister and bearing a message about death. But the minute you said it, it seemed obvious. Of course that's what it's about! I compare it to the self-portrait (pl. 14) with Kertész's shadow and the shadow of the camera—an amazing counterpart to *Martinique*.

CH: In the self-portrait the profile is so recognizable that it looks like an X-ray. There is still a reference to the body, to Kertész as a physical being. Here, though, the figure looks as if it were sprayed on.

I want to ask about Kertész's sentimental side. Here we have a picture of a cat from 1928 (pl. 21).

DT: The fact that in this picture he dips down into something that every cat-lover would love doesn't discredit his other achievements.

CH: Is he ever deeply emotional? Do you think of him as being passionate?

WN: The cat picture is a strong portrait, but not sentimental at all and comparable in its formal austerity to Albert Renger-Patzsch's ostrich resting, or his orangutan.

SP: This cat is very feminine, much like some of Kertész's pictures of women.

WN: I think also of the portrait of Elizabeth with Kertész's hand on her shoulder (pl. 51). We have no portraits of Rosza Klein, Kertész's first wife, and I have imagined this as a portrait of her.

CH: Kertész moved from Paris to New York in 1936. We've talked about Hungary, we've talked about Paris. Now Kertész makes his second reincarnation, in a way, takes his second big leap.

DT: Or perhaps his fiftieth!

CH: Right. But when he comes here he talks about himself as a corpse, a buried man. Was he an exile at that point?

DT: Many artists and writers in the twenties found America so grossly commercial that they left for Europe. The painters of the Stieglitz circle were unhappy that they couldn't make a living by selling their work, and they felt America was just not culturally supportive. I think Stieglitz realized that it was just a harder sell, that there were people who would buy, but that he would have to work at it. But I think others dreamed that Europe would be better, not only as a place to work but also to profit from. And when they got there, I'm sure they found out that people there didn't shell out lots of money, either.

But I think it's very hard for any of us to understand what it would be like to step on this continent with only the vaguest sketches of what life would be like in America. It was a very promising country in the Modernist sense, in that it was going to fulfill what the Russian Revolution was aiming for. As Gertrude Stein said, they were actually going to live the twentieth century in America.

So it must have been horrible for him to find out that these people only wanted him to be a point-and-shoot assignment photographer, and that the business was all very commercialized. He must have thought, "I really made a mistake."

WN: Pictures of the apartment at 2 Fifth Avenue, where he lived for approximately thirty years, show it as a very European place. It was filled with semi-antique objects of some historical or cultural value, as well as with the kitsch objects that he loved and bought in tourist shops. So the contradiction for me, given how often he said he hated New York and loved Paris, is that he seemed so comfortable here, so satisfied with his daily life walking through Greenwich Village.

DT: It could be that by the time we knew him, he had acclimated himself. It would have been interesting to know him in 1938. Was he crabby? Did he put off everybody he met?

SP: I think he eventually found his vision here—until you do, you are not at home. Once he saw his view of Washington Square Park and the rooftops from his window, it allowed him—

DT: He found Paris in New York.

SP: Maybe it wasn't even Paris that he found, but something in his heart. But the wonderful thing about the park—it's right there—it's the Arc de Triomphe.

DT: Take, for example, *Melancholic Tulip* (pl. 44), made in 1939, two years after he arrived in New York. It is hardly full of joie de vivre, but it has a playful touch.

CH: I relate this back to *Chez Mondrian* (pl. 17).

SP: Yes. I always assumed it came from the same period. I didn't realize he made it in this country.

CH: Another theme in a lot of his work here is the soulless walls of skyscrapers, juxtaposed with things like crosses or clouds. If you compare *The Lost Cloud* (pl. 42) with *Rue Vavin* (pl. 8), you have two very different images of a wall. One opens to interesting vignettes, the other is absolutely impossible to get into or through. There is a very strong sense of the coldness of this country.

DT: Yes, things are distant, removed. It's a bigger country. It's not at the cafe-table scale, where he was so successful with those still lifes. But he was able to make vistas like this. Think of the trouble Edward Weston had going from architectonic

still lifes and details to the big-sky pictures he made in New Mexico. He had done a few, in Mexico, but they are rather sparse. Kertész started out as a still life photographer, so for him to take a picture like this is surprising. In Paris his scale was often only a tabletop, and here he's dealing with the Empire State Building.

RG: This is important. The scale of André's imagery and his ultimate understanding of scale is based on the fact that he first photographed with a camera that produced glass plates approximately equivalent in size to a contemporary 35-millimeter negative. He wasn't able to enlarge prints at first, so he was limited. He had to be able to see in that size; the scale became tantamount to the image. Later, in Paris, the *cartes postales* were probably big for him at the time. He went on to work in other sizes, but basically learned to "see" with contact prints of a small size.

DT: The pictures in his New York–Paris book are nearly actual size—really tiny, but very graphic. People here, fields, then houses. He's one of the people, like Paul Outerbridge, who could work well small. I think it came from working with still lifes and not cluttering the frame. If you take one of his still lifes, it is usually a Modernist composition, sparse and spare, and it's perfect.

WN: Charles has placed *The Lost Cloud* (pl. 42) and *Martinique* (pl. 54) side by side, and we should discuss why they go together. Part of it has to do with the line created by the edge of the frosted glass.

DT: But both also deal with vastness.

SP: And in each there is a lone figure—in one it's the cloud, in the other it's reversed and the cloud becomes the overwhelming space.

DT: Right. In one he's the cloud and in the other he's the figure going out into the vastness.

RG: I laughed when I first saw *The Lost Cloud*. Here is this little cloud peeking around the edge of the building—

SP: It's very funny.

RG: I've always seen it as André looking around the corner, seeing what there is to see. And then I read the title and said, "Oh, what a shame. It is he that is lost."

DT: You could see it almost as an illustration in a children's book. Can we talk about how Kertész shifted into this mode of reexamining his own life? I see that as a dominant aspect of his work in New York.

CH: We talked about how he would go back and print up pictures from Hungary, sometimes framing them differently to bring out symbolic meanings. He also did the late still lifes, the Polaroids and windowsill pieces.

RG: He even included old photographs in still lifes, like the picture of the distorted nudes behind the model of *The Last Supper*, or the picture where he placed a crown of thorns on the print of *Elizabeth and Me*. He was always reinventing himself and at times reinventing old images. However, some of this was practical. After Elizabeth died, he spent a lot of his time in his apartment, a bit frail himself, in mourning, trying to process what had happened to him, looking back at objects he had collected through the years and at old images he had made. For him to see this in a new light is quite natural. What is remarkable is that he recorded it.

WN: In terms of reevaluating his own life, *The Broken Bench* (pl. 49), from 1962, is a key image. All the elements of his biography are present here, and yet few people know all those elements. In the foreground is Frank Thomas, the mysterious figure who may have been descended from a Paris millionaire, who was André and Elizabeth's best friend in New York. He's seen from behind, almost like the aristocrat standing in the Tuileries Gardens with his cane behind him in Kertész's picture from 1926, *On the Quais*.

WN: André told me that this man, whose Hungarian name was Ferenç Tamas, had traveled from Hungary to Paris, where they met each other; he came to New York in 1937. André said Thomas was Elizabeth's partner in business—and a good friend. In New York he became partners with Elizabeth in the cosmetics business. But soon after this he became blind and totally reliant on the Kertészes.

SP: I think Elizabeth was the one who took care of him.

RG: Yes. A lot of the other images that André took of him appear to be family snapshots that are very mocking and show him in unflattering circumstances.

WN: The story continues. Elizabeth pursued a number of hobbies, among them painting and dancing. At one of her dance classes she noticed a girl who always stayed in the corner, apart from everybody else. Elizabeth and André befriended her, invited her up to their country house for the weekend. During the weekend the girl went berserk and had to be committed to a hospital. This picture was taken on the hospital grounds, with Elizabeth in the background, consoling the girl. So this is an incredibly pregnant picture, full of biography. You can easily pass over it as merely an interesting exercise in the intersection of accident and chance, that André was strolling through Central Park, say, and saw the broken bench and the man, and that the people in the distance are no relation whatsoever. But once you know the entire story, the picture becomes extraordinary. It seems telling, too, that this picture is not titled *My Friend Frank Thomas* or *My Wife Elizabeth and Her Friend*, but *The Broken Bench.*

DT: But what does André expect anybody who doesn't know the story to get out of the picture? So much of photography is coincidental. Here the people are not symbols. They are themselves! But we read it as a set of symbols.

CH: How much should we speculate about what these pictures mean, on the basis of what we know of Kertész's life?

DT: You can speculate all you want. It shows your inventiveness, but as you learn more you can discard some of those speculations. Mathematician friends have tried to explain what they think math is. They say the whole thing is about getting to the right conjecture. You're going to have plenty of conjectures that are inventive, but you can waste a whole career on something that leads to nothing.

The same is true here. You start your conjecture based on what little you know, even on just the formal elements: here you have a dark man looking at a broken bench. The more you know about Kertész, the more powerful the picture becomes. But it still started out as a fairly powerful picture.

WN: What I'm saying today are facts; none of this information is speculative. Once those facts are known and accepted, do they change the picture at all?

DT: That's an interesting question. You don't quite know if there are two ladies or three—you have to look. And now you learn that they all know each other!

WN: Not only know each other, but their destinies are significantly intertwined. The girl is about to be released from the hospital where she was committed, and she could only be released into someone's custody. Kertész told me he and Elizabeth agreed to be responsible for her. So here before us is the man who for fifteen or twenty years they cared for, as well as their next charge, the replacement for the child they never had.

SP: So *The Broken Bench* as a title is perfect! They have lost all comfort.

WN: By comparison, André's life had none of this drama during the period when we knew him. He was either taking care of Elizabeth, who was sick most of the time I knew her, and after she died he was a man freed from responsibilities, able to receive a stream of visitors every day, most of them adoring. Before that day, no one was permitted into the apartment!

SP: No, when Elizabeth was there, I did not visit as often as later on. But André loved visitors.

DT: That's true. In Paris, you could probably see most of your friends by going to the Dôme or just calling on them. People didn't always phone in advance and make appointments—they showed up. New York must have been very different. But again, at the end, so many people came, and film crews and all.

SP: I think later it just became habit for him to say how much he really didn't like it here. Because he did like all the company!

CH: Are you saying that he actually wasn't as bitter as he acted?

SP: Yes.

WN: My perception is the same.

SP: He was in the habit of being bitter.

RG: I always thought his bitterness was a useful tool that served many functions for him. It allowed him to retell his history in case one of us got it wrong. It was

also a barrier, a suit of armor. As we are suggesting today, much of his work is autobiographical. He exposed some very personal, raw material. The bitterness must have been a shield to protect him from some of his more vulnerable imagery.

Also, with the hordes of people knocking on his door in the late seventies and eighties, it had to be a screening device. I experienced this. It was only after I accepted the fact that he was not the upbeat person he presented himself to be in his images that he let me in on his personal life. You had to work through the negativism to get to the charming, creative side of him. Most importantly, at times it was his fuel. On numerous occasions I saw him change from an angry, bitter old man to someone who seemed much younger, photographing furiously. One minute he was worked up about something that had been done to him, and the next minute he was transformed by an image that caught his eye.

From his perspective, over the course of thirty years, many unfair things happened to him in the United States. Yes, he became angry and bitter, but he learned how to use it to his advantage. No, it wasn't an overwhelming aspect of his personality. We wouldn't be sitting here today if he hadn't charmed the pants off us.

WN: Whenever he was around me or my family, he was a person of great ebullience, of charm, of release from whatever bondage he may have found himself in.

SP: It's just the Weltschmerz of a Hungarian. It is cultural.

RG: In the seventies André had people to share his photographs with again who understood and revered him.

WN: This is very important. The audience finally understood.

SP: Not just the audience, but you, Weston, and David, you understood also. What's more, you also could help him get shows and books.

CH: Is he a traditional artist? An innovator? Sentimental? Modernist?

DT: Through the whole period, he is someone who doesn't change much. You see it in Budapest, in Paris, in New York. He didn't change with every direction of the

wind. In the end, you admire an artist who is complicated enough to take a whole career to explain himself. But when you write the kind of things we write—taking the temperature of photography, what the intellectual climate was—these people suffer enormously for being out of sync. By the seventies, when photography was really on the rise, there was a certain group of people who admired him, and then there were people who said, that kind of photography died a long time ago.

But even in his last works he is able to engage us. He can still touch a sentimental vein, retreat, and make it meaningful, even in an age of Lucas Samaras doing Polaroids. It wasn't just sentimental. He wasn't making greeting-card photography. It's interesting if you couch it in terms of a century that changed so much.

CH: Was he a figure of the nineteenth or the twentieth century?

DT: He was a twentieth-century person. He started pretty far back, but he was well rooted in who he was and didn't need to change enormously. But he wasn't afraid of the things that were changing. And again, like many people after World War I, he felt there was a way to reconstitute the world—psychologically, physically, artistically, even politically. So I am grateful, in a way, that he didn't change much. Because he could go through almost the whole century with a very keen eye.

CH: I find it fascinating that he tried to change himself so often—he went to Paris, he came to the States—but then he ended up going back to Hungary in his pictures. There's a strong sense of his being a Modernist and trying to reinvent himself, to be free from his past—and he ends up, in fact, going back through memory, too.

DT: It's pretty remarkable. If you take almost any other figure, even with a long career, they flower beautifully in a certain period, but not over sixty years.

RG: As fashion changed, he could borrow from it, incorporate it into his vision, without becoming a Surrealist, without becoming a Modernist, without becoming any of the genres that he used in his photography. The thread through it all is his desire to express himself.

WN: I didn't know many of the things we have discussed today, these nuances and facts of his life. When I thought of his work as great, I merely had the work

itself as inspiration. So in response to the question of whether he was a conservative or something else, I will answer that to me that was the attraction. He could do work that was sometimes so *retardataire*, so reactionary, so sentimental; and yet, at other times, butt it seamlessly against work that was so formal, so intelligent, so rigorous, so demanding, so deeply imbued with insights from the Freudian revolution. The pictures we have talked about most today are the ones whose content is buried deep inside, and we have tried to touch the nerves of the pictures themselves.

DT: Unlike many of his colleagues, he always wanted to be a photographer. I don't think Henri Cartier-Bresson ever considered when he began that he would be a professional photographer. Brassaï certainly did not aim for it. Man Ray didn't want to be known for it. As for the Americans, I think Strand did; Stieglitz, too, must have decided that this was going to be it for him. But André, among all the people who began with Modernism, didn't back into it from journalism, painting, or any other career.

Now, it was an invigorating virtue to come from another field and bring something to photography or to become a photographer. But it didn't hurt him at all to want only to be a photographer. It seems like such a small goal in a period when photographers weren't admired at all, but he kept with it and didn't say, "Well, maybe I will be a painter or a sculptor," something people could admire!

WN: Underscoring what I said earlier, André was a photographer's photographer, and he loved and respected photography. In his library he had books like Helmut Gernsheim's *History of Photography* signed and inscribed to him. He even had Beaumont Newhall's edition of H. H. Hunt's earliest history of photography published in America. He made his own self-portrait in 1917 as a camera under the trees in Hungary. When he attended the first modern sale of photographic images at auction—the Strober sale of 1970—he remarked to me, "I am fascinated by the fact that people love these pictures. Somebody values them!" He was deeply committed to being a photographer and nothing else.

RG: I'd like to add his explanation of how he became interested in photography. It came from looking at magazines in his uncle's attic. In response to the etchings

and drawings that were used for illustrations, he said, "I wanted to see if I could do with the camera what they were doing in the magazines." He was inspired by other artwork and projecting what he could do with the camera—the initial influence was not other photographs.

DT: As I say, the more we think we know, the more we like to congratulate ourselves by applying it to the pictures. But they do have a life that doesn't have to be accompanied by commentary. And therein lies their success.

SP: One thing in closing: André was a crusader for small causes. For him, a moment, a bird, a cloud, any small thing was worthy of attention; and to be a photographer meant to devote his life to his small and humble craft. Except that by doing it so well, he was an artist.

Chronology

1894

André Kertész is born July 2, the second of three sons, to a Jewish father and Christian mother, Liopot and Ernestine Kertész, in Budapest, Hungary.

1909

Father dies, leaving Ernestine to raise the boys. At family reunion Kertész sees collection of drawings, woodcuts, and other pictures dating from the previous century. Education includes instruction in the Hebrew language.

1911

Buys first camera and begins photographing around Budapest. His brothers, Imre and Eugenio, are frequent subjects.

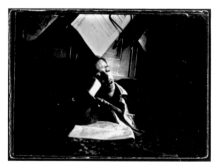

André Kertész. *Boy Sleeping in Cafe* [untrimmed contact print], May 25, 1912. Gelatin silver print, 19.8 x 24.8 cm. © André and Elizabeth Kertész Foundation.

1912

Graduates from business college and is employed as a clerk at the Budapest stock exchange. Begins using ICA box camera, which holds twelve small glass plate negatives, to shoot spontaneous studies, including *Boy Sleeping in Cafe,* his first masterpiece.

1914

Is inducted into the Austro-Hungarian Army. The daily life of his fellow soldiers becomes a chief subject. He collects postcards depicting war scenes and landscapes, which contribute to his visual education.

1915

Is wounded in battle.

1916

Is hospitalized in Esztergom to recover from a bullet wound that temporarily paralyzes his right arm; has much free time to photograph (pls. 1–2).

1917

Photographs *Underwater Swimmer* (pl. 3). Publication of first photographs in *Erdekes Usjag* (Interesting Newspaper).

Circa 1918

Makes negatives during the war that are later destroyed during the Hungarian Revolution in 1956. After discharge, returns to Budapest, where he meets Erezsebet Salomon (later Elizabeth Saly) at the office where they both work.

1919

Photographs *The Dancing Faun* (pl. 5), with Eugenio Kertész as his model.

1921

Takes leave of absence from his office job to live with an artist in the village of Abony, where he also learns beekeeping (pl. 7).

1922–25

Lives in Budapest, where he succeeds in having his pictures reproduced in the picture press. Erezsebet is his constant companion.

1925

Relocates to Paris from Budapest. Meets many other Hungarian artists, composers, journalists, and writers there, including Paul Arma, István Beöthy, Brassaï, Noémi Ferenczy, Jozef Csáky, Gyula Silzer, Lajos Tihanyi, and Marcel Vertès. His first Paris photographs are atmospheric and descriptive (pls. 8–12).

1926

Moves into apartment at 5, rue de Vanves in Montparnasse, where he lives until 1928. Visits Mondrian's studio (pl. 17) and commences what will become a series of photographs representing the studios of artist friends (pls. 22–25, 34).

1927

Meets Herwarth Walden, director of Der Sturm gallery, Berlin. Walden is friends with Jean Slivinsky, director of Galerie Au Sacre du Printemps, where Kertész's first exhibition opens on March 12 (pl. 15). The journal *L'Esprit nouveau*, founded with the collaboration of Le Corbusier in Paris, publishes work by Kertész.

1928

Purchases Leica camera and uses it to create *Meudon* (pl. 30). Marries Rosza-Joséphine Klein (b. 1900). Receives copy of Albert Renger-Patzsch's book *Die Welt ist schön* from Anna-Marie Merkel (pl. 19). Work included in camera club exhibitions in Paris, Brussels, Ostende, and Prague.

1929

Represented in exhibitions *International Austellung Film und Foto*, Stuttgart, and *Fotografie der Gegenwart*, Dresden. Publication of first major article on his work in *L'Art vivant* by Jean Gallotti, "La photographie est-elle un art?"

1930

American debut of his work appears at New York Art Center in *An Exhibition of Foreign Photography*. He separates from Rosza Klein. Awarded silver medal for work in *L'Exposition coloniale,* Paris; group exhibition at Gewerbesmuseum, Basel. Pictures are bought for reproduction in numerous illustrated magazines in Europe.

1931

Erezsebet Salomon (now Elizabeth Saly) immigrates to Paris; she and Kertész reunite and move to rue du Contentin apartment. Kertész exhibits with Association Belge de Photographie, Brussels, and the Royal Photographic Society of Great Britain.

1932

Included in *Modern European Photography* show at the Julian Levy Gallery in New York.

1933

Mother dies; Kertész returns to Hungary for funeral. Marries Elizabeth. First book, *Enfants,* with sixty photos and text by Jean Nohain, is published. Completes the Distortions, a series of some two hundred pictures of nude women reflected in a parabolic mirror.

1934

Distorted nudes exhibited at design showroom of Leleu. Second book, *Paris Vu par André Kertész,* with introduction by novelist Pierre MacOrlan, is published.

1936

Nos amis les bêtes is published. First issue of *Life* appears, November 23. Advent of *Life* perhaps inspires Kertész's interest in New York (pls. 41–52), where he goes with Elizabeth and remains for the rest of his life.

1937

First solo exhibition in New York, consisting of sixty photographs at PM gallery. Makes *Arm and Ventilator* (pl. 41) and *The Lost Cloud* (pl. 42). Work published in *Coronet* and *Harper's Bazaar*. Five photographs are included in Beaumont Newhall's epochal *Photography, 1839–1937* exhibition at the Museum of Modern Art.

1939

Commissioned by *Life* to prepare personal reportage on the New York maritime trades (pl. 45), but his work is not published. He meets Alfred Stieglitz and Frank Crownin-shield, editor-in-chief of *Vanity Fair*. Creates *Melancholic Tulip* (pl. 44).

1941–45

As a Hungarian citizen, Kertész is registered as an enemy alien by the United States government and is forbidden to photograph outdoors. For the next four years he photographs very little. In 1941 Elizabeth establishes cosmetics firm in partnership with Frank Thomas (Ferenç Tamas). One photograph is included in the *Image of Freedom* exhibition at the Museum of Modern Art, which purchases *Armonk* for its collection. In 1945 the book *Day of Paris*, with text by George Davis, is published in New York. Begins regular work with *House and Garden* magazine.

1946

Fifty photographs selected by curator Hugh Edwards are exhibited at the Art Institute of Chicago, Kertész's first serious recognition since arriving in America.

1949

Signs exclusive contract with Condé Nast Publications to work under the direction of Alexander Liberman at *House and Garden*. Between 1945 and 1962 more than three thousand of his photographs are reproduced in its pages, thus precluding personal work.

1952

Moves to 2 Fifth Avenue, occupying a two-bedroom apartment overlooking Washington Square.

1962

Is hospitalized for minor surgery. While recuperating, decides to resign from *House and Garden* in order to work independently. Creates *The Broken Bench* (pl. 49).

1963

Travels to Paris for the first time since his emigration; recovers negatives saved for him during the war, including *Broken Plate, Paris* (pl. 50). Solo exhibition in Paris at the Bibliothèque Nationale; small catalogue with text by Alix Gambier.

1964

Exhibition of fifty-one photographs at the Museum of Modern Art selected by John Szarkowski; small publication.

1966

Begins association with Igor Bakht, a skillful darkroom technician, who makes exhibition and reproduction prints from Kertész's negatives. Begins association with Grossman Publishers, Inc., which issues a small-format survey of selected work from 1912 to 1966 with text by Anna Fárová.

1968

Travels to Tokyo (pl. 53), where the exhibition *The Concerned Photographer*, organized by Cornell Capa and including approximately thirty Kertész photographs, is installed.

1970

Included in the *Photo Eye of the Twenties* exhibition, selected by Beaumont Newhall and installed at the George Eastman House, Rochester, and the Museum of Modern Art.

1971

Begins association with Nicolas Ducrot, who edits a series of small monographs reminiscent of Kertész's Paris monographs, commencing with *On Reading* and eventually including *Washington Square* (1975), *Distortions* (1976), *Of New York* (1976), and *Americana, Birds, Portraits, Landscapes* (all 1979).

1972

Grossman publishes *André Kertész: Sixty Years of Photography*, with 226 reproductions spanning the years 1911 to 1972.

1973

Vacations with Elizabeth in Martinique and creates *Martinique* (pl. 54), his late masterpiece.

1977

Elizabeth dies in New York.

1973–85

Kertész continues to photograph, often returning to themes and strategies established sixty years before. Is honored by an international array of exhibitions usually consisting of prints made under his direction by Igor Bakht. Receives honorary degrees, ribbons, and medals from universities; professional organizations and ministries of culture and education of several countries honor him.

1985

Kertész dies in New York on September 28, just before the opening in New York of the exhibition *André Kertész: Of Paris and New York*. Organized by the Art Institute of Chicago and the Metropolitan Museum of Art, New York, and selected by David Travis, Weston Naef, and Sandra Phillips, it is the first museum survey of Kertész's art consisting solely of prints made contemporaneously with the negatives. (For a thorough bibliography of books by and about Kertész, see pages 280–85 in the exhibition catalogue.) Out of respect for the strong influence of France on his creative life, he bequeaths negatives and correspondence to the French Ministry of Culture.

Robert Gurbo. *Bookshelf, Kertész's Study,* 1985.
From the Chez André series.
Gelatin silver print, 4.6 x 11.4 cm. © 1993 Robert Gurbo.

Editors	John Harris
	Mollie Holtman
Designer	Jeffrey Cohen
Production Coordinator	Amy Armstrong
Photographer	Ellen Rosenbery
Typesetter	G & S Typesetters, Inc.
	Austin, Texas
Printer	The Stinehour Press
	Lunenburg, Vermont

Left to right, standing: Charles Hagen and David
Travis; *sitting:* Sylvia Plachy, Weston Naef,
and Robert Gurbo. Photograph: Melvin Simmons.

Contributors

Robert Gurbo is Curator of the André
and Elizabeth Kertész Foundation.

Charles Hagen is art critic for the
New York Times.

Weston Naef is Curator of Photographs
at the J. Paul Getty Museum.

Sylvia Plachy is a photographer in
New York City.

David Travis is Curator of Photography at
the Art Institute of Chicago.

On the front jacket:
André Kertész. *Arm and Ventilator, New York,* 1937.
Gelatin silver print, 13.6 x 11.3 cm. 85.XM.259.15.

On the back jacket:
André Kertész. *Kertész in His Darkroom, Paris,*
1927. Gelatin silver print, 8 x 10.5 cm. 86.XM.706.8.

André Kertész. *Kertész in His Darkroom, Paris,* 1927.

This is the first in the Getty Museum's new In Focus series of books, each devoted to a photographer whose work is particularly well represented in the Museum's collection.

In Focus: André Kertész reproduces more than fifty Kertész photographs, with commentaries on each by Weston Naef, the Getty Museum's Curator of Photographs. Included as well are excerpts from a discussion of Kertész's life and career by five people uniquely qualified to assess his work: Robert Gurbo, Charles Hagen, Weston Naef, Sylvia Plachy, and David Travis; and a chronology of significant events in Kertész's life.

ISBN 0-89236-290-1